LEGENDARY LOCALS

OF

BEACON HILL

MASSACHUSETTS

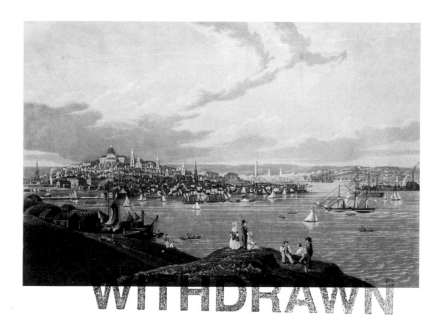

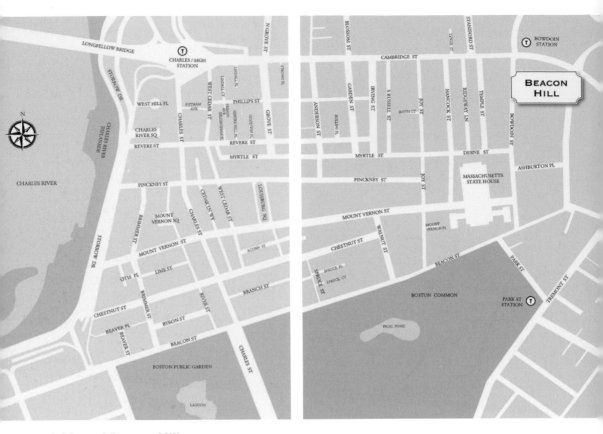

A Map of Beacon Hill
The neighborhood is nicely situated amid the Boston Common and Public Garden, the Charles River Esplanade, state office buildings, including the Massachusetts State House, and the street leading to Cambridge over the Longfellow Bridge. (Beacon Hill Garden Club.)

Page 1: A View of the City of Boston from Dorchester Heights
The Massachusetts State House upon Beacon Hill has a commanding presence in this engraving, made about 1841. Church towers and the Bunker Hill Monument in Charlestown are other notable features. It is possible to see Beacon Hill's Beacon Street houses to the left of the State House. (Boston Public Library.)

LEGENDARY LOCALS

OF

BEACON HILL

MASSACHUSETTS

KAREN CORD TAYLOR

LEGENDARY
LOCALS

Legendary Locals is an imprint of Arcadia Publishing
Charleston, South Carolina

Printed in the United States of America

Library of Congress Control Number: 2013955326

For all general information, please contact Arcadia Publishing:
Telephone 843-853-2070
Fax 843-853-0044
E-mail sales@arcadiapublishing.com
For customer service and orders:
Toll-Free 1-888-313-2665

Visit us on the Internet at www.arcadiapublishing.com

Dedication
For the courteous, dignified, witty Grand Old Man of Beacon Hill, John Winthrop Sears.

On the Front Cover: Clockwise from top left:
Gurnon family members and their staff at Charles Street Supply (Gurnon family; see page 83), John Hancock (City of Boston and the Museum of Fine Arts, Boston; see page 15), Marika Raisz, founder of Marika's Antiques (Matt Raisz; see page 78), John J. Smith, barber, legislator and abolitionist (Museum of African American History; see page 47), authors at Blackstone's on Beacon Hill (Blackstone's of Beacon Hill; see page 103), John Sears, public servant (*Beacon Hill News* archives; see page 90), Dr. Oliver Wendell Holmes, author and medical doctor (King's Chapel archives; see page 51), John Codman, neighborhood leader (*Beacon Hill News* archives; see page 70), Connaught and Gael Mahony, neighborhood leaders (Mahony family and photographer Amy Rader; see page 85).

On the Back Cover: From left to right:
Eugenie Beal and Henry Lee with friends and accomplices (*Beacon Hill News* archives; see page 86), Young members of the Union Boat Club (Joseph L. Eldredge, FAIA; see page 65).

CONTENTS

ACKNOWLEDGMENTS

Thanks go to the following people for telling me their stories and plying me with photographs: Samantha J. Goudreau and MaryLee Halpin, Beacon Hill Civic Association; Kate Enroth, Beacon Hill Circle for Charity; Janie Walsh, Beacon Hill Garden Club; Lucinda Ross, Beacon Hill Nursery School; Carolle Morini and Peter Walsh, Boston Athenaeum; Prof. Jeffery Howe, Boston College; Arthur Pollock, *Boston Herald*; Jane Winton and Aaron Schwartz, Boston Public Library; Jim Wood, Church of the Advent; Liz Vizza, Friends of the Public Garden; Sara Garber and Kristina Kashanek, Goody Clancy; Kathy Kottaridis and Stanley Smith, Historic Boston; Penny Leveritt, Historic Deerfield, Inc.; Lorna Condon, Abigail Cramer, and Susanna Crampton, Historic New England; William Kuttner, King's Chapel; Christine Wirth, Longfellow House-Washington's Headquarters National Historic Site; Garyfallia Pagonis and Chris Nims at the Massachusetts Eye and Ear; Jeff Mifflin, Massachusetts General Hospital; Victoria Donahue, the Museum of Fine Arts, Boston; Marilyn Schacter and Beverly Morgan-Welch, Museum of African American History; Flavia Cigliano, Nichols House Museum; Sr. Kristina Frances and Sr. Adele Marie Ryan, Sisters of St. Margaret; Rachel Spilecki, Vilna Shul; Duane Lucia, West End Museum; Sally Hinkle; Dr. Joseph Ingelfinger; Steve Judge; Nancy Macmillan; William Owens; Medb Sichko; Peter Thomson; and all the Beacon Hill families who helped with this project.

In courtesy lines for images, some sources have been abbreviated as in the *Beacon Hill News* archives (BHN), the Boston Public Library (BPL), the Beacon Hill Civic Association (BHCA), the *Beacon Hill Times* archives (BHT); Historic New England (HNE), Massachusetts General Hospital (MGH); the Museum of African American History (MAAH), and the Nichols House Museum (NHM).

INTRODUCTION

First, get your bearings. Beacon Hill is a neighborhood in downtown Boston. About 9,000 residents live in a rough square about a quarter mile long on each side.

Not all of Beacon Hill is on a hill.

The western edge of the neighborhood is at Storrow Drive along the Charles River. That part is flat until it meets Charles Street, where it begins to rise. Flat terrain in Boston is likely to be filled land, and that is what happened to the flat of the hill. It was created in the 19th century from soil and rubble scraped off the top of three hills, known as Trimountain, when Boston was first settled. A beacon was erected on the highest of those hills in 1634. Now at the top of that scraped-down hill sits Charles Bulfinch's Massachusetts State House, the early copper dome of which was fashioned by Paul Revere's foundry.

On the south, Beacon Street separates the neighborhood from the Boston Common and the Boston Public Garden. This side of the hill is called the south slope.

The eastern edge is now Bowdoin Street. The boundary used to be past Somerset Street, but in the mid-20th century, officials bulldozed ancient streets in a development frenzy and the state built high-rise office buildings on those blocks.

On the north, the Beacon Hill neighborhood stops at Cambridge Street. This side of the hill is called the north slope.

Boston began in 1630 as a British colonial city settled by Puritans, many of whom came from the port city of Boston, England. They first settled in Charlestown. But water was scarce, so they moved across the Charles River to the Shawmut Peninsula, which is the location of downtown Boston now.

Beacon Hill houses are not from the colonial period. Except for a few notable houses overlooking the Boston Common and a few small houses running down the hill toward the north, Beacon Hill was mostly orchards, pasture, scrub, and marsh until 1798 when the Massachusetts State House was finished. After the State House set the tone, real estate developers began building in earnest.

Housing styles follow the history and slope of the hill. Most of the earliest houses, built around 1800, are at the top of the hill. These are Federal in style.

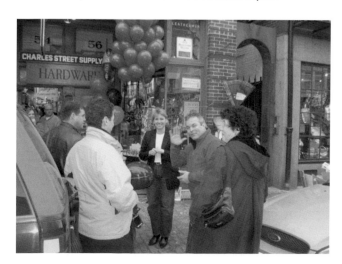

A Neighborhood Gathering Place
Charles Street Supply owner Jack Gurnon and wife, Cassie, are always ready to throw a party. Their store is a place to meet one's neighbors. (BHT.)

By the 1840s, more housing had been built on the lower slopes. During that period, the Greek Revival style became fashionable. The flat of the hill was filled in gradually over about a century. Many of the houses in this area are Victorian-era row houses, converted carriage houses or stables, or they were built in the Colonial Revival style in the early 20th century. Flat-roofed tenement buildings now occupy much of the north slope of the hill. They replaced small workers' houses in the late 19th century to accommodate the influx of eastern and southern European immigrants arriving on these shores.

Housing styles are important to those living on Beacon Hill. The buildings are mostly old and well preserved. They are governed by the Beacon Hill Architectural Commission, which must approve every change "visible from a public way" that owners make to their houses. This includes repainting a front door in the same color.

Tour bus guides seem fascinated by the wealth in the neighborhood, but those who live here prize most Beacon Hill's sense of community, its walkability, and its quirkiness. Again and again, those whose pictures appear in the latter part of this book said they moved to Beacon Hill because they would always find someone more eccentric than they were.

Beacon Hill residents staunchly defend the neighborhood's bricks, its ever-burning gaslights, its row house architecture, its trees, and its one-of-a-kind shops, the combination of which are difficult to find elsewhere.

Despite its unique character, this neighborhood is not isolated. It is easy to get to all parts of the city from this neighborhood, either by foot, bike, T, or taxi.

And it does not exclude outsiders. Beacon Hill residents welcome all ethnicities, races, religions, and styles of life. It is a tolerant place, as long as everyone picks up after their dogs and puts the trash out properly.

Those who live here are happy to share their blessings with tourists and visitors. You are invited to ply the sidewalks, peer into windows, look down walkways, and sample the shops. The neighborhood opens its outdoor spaces formally at the annual Hidden Gardens Tour on the third Thursday in May and at the Beacon Hill Art Walk, which takes place in the nooks and crannies of the north slope on the first Sunday of June.

The people who live here believe it has been a special place to live, work, and enjoy for more than 200 years. This book profiles some of the people who have made it so.

Mount Vernon Street
Beacon Hill residents prize such row houses as these. Some house only one family, but many have been divided into multifamily condominiums or apartments. Neighbors share walls, doors, chimneys, walkways, gardens, ceilings, and floors. (BHT.)

CHAPTER ONE

From Boston's founding in 1630 until after the American Revolution, the area that is now the Beacon Hill neighborhood was considered the country. Its hills were known together as Trimountain, and they consisted of steep, scrubby slopes, farmland and pasture, a few orchards, springs, wells, a marshy edge along the Charles River, a powder house built in 1770, and a few ropewalks. On one slope lived an eccentric early settler, Rev. William Blaxton (Blackstone). Some described him as cranky, while others said he was misanthropic for having sold his land when the humanity of colonial Boston pressed in on him. Or that is the story.

The neighborhood's terrain was originally characterized by three summits left by an ancient glacier. Sentry Hill was the middle hill and rose the highest. When a beacon was placed on its top, it became known as Beacon Hill. To the north, connected by a ridge, was Pemberton or Cotton Hill, named after the Rev. John Cotton, who lived at its base. Just above the present-day Louisburg Square rose what was eventually called Mount Vernon.

Beacon Hill is the only peak left standing, but it is reduced by more than 60 feet from its original glory. The other two summits are gone, leveled by a desire for a more accommodating slope on which to construct buildings and by the need for fill to make more land in marshy, postcolonial Boston.

Eventually, the grand mansion built by John Hancock's uncle Thomas Hancock and a substantial farmhouse occupied by the family of the portrait painter John Singleton Copley beautified the land extending to Trimountain's highest peak. These properties had the advantage of looking over Boston Common, but enjoying peace and quiet far above the hurly-burly of Dock Square, the North End, and the wharves.

A community of small houses, some made of wood, extended to the north toward Cambridge Street, the area having been laid out in streets in the first half of the 18th century. To the east such speculators as Harrison Gray, grandfather of a future Boston mayor, and Dr. Thomas Bulfinch, grandfather of Charles Bulfinch, the architect of the Massachusetts State House, the US Capitol and many fine houses, bought up land and held it or sold it.

Because of its sparse settlement, Beacon Hill missed much of the excitement leading up to the Revolution. During late colonial times the Boston Tea Party and the Boston Massacre took place near the wharves and the Old State House. Paul Revere waited across the Charles River for the signal from the Old North Church in the North End. The colonists fought in Charlestown at the Battle of Bunker Hill.

Nothing much happened on Beacon Hill until, in a fury of patriotic sentiment with a dose of real estate development dreams, the Massachusetts State House was built. The rest is the history celebrated in this book.

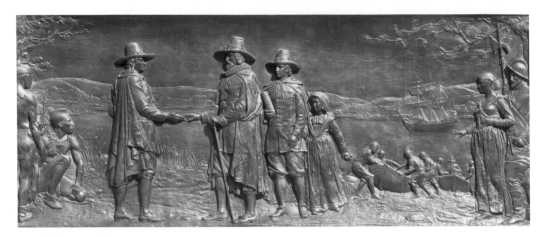

William Blaxton's Contribution to the "City Upon a Hill"

When John Winthrop and his band of Puritans sailed into Massachusetts Bay in 1630, their vision was lofty. They intended to create a "City upon a Hill," the Puritans' version of utopia, with "the eyes of all people . . . upon us."

But there was not just one hill. There were many.

The Massachusetts Bay Colony, as Winthrop's band was named, alit in Charlestown, which had Breed's Hill and Bunker Hill. But fresh water was scarce. They decided to move across the Charles River to the edges of Trimountain on the Shawmut Peninsula, but first they had to deal with the Rev. William Blaxton.

The Reverend Blaxton had settled on several acres of land on the Shawmut Peninsula in 1625. Winthrop and Blaxton struck a deal in 1630 in which the colony would occupy the portion of Shawmut near the harbor and Blackstone would stay near his orchards on Trimount's slope.

Blaxton was a solitary person. Perhaps those new arrivals a short distance away were too much for his sensitivities. In 1634, he sold the rest of his land, including that which would become Boston Common. He retained six acres near the present-day corner of Beacon and Charles Streets. But soon, he moved to Rhode Island, where he died in 1675.

Sculptor John Francis Paramino imagined Blaxton handing over his property to Winthrop in a bronze relief sculpture, titled "The Founding of Boston," located on the Boston Common. Another artist depicted his cabin against Trimountain. (Above, Tom Coppeto; below, BPL.)

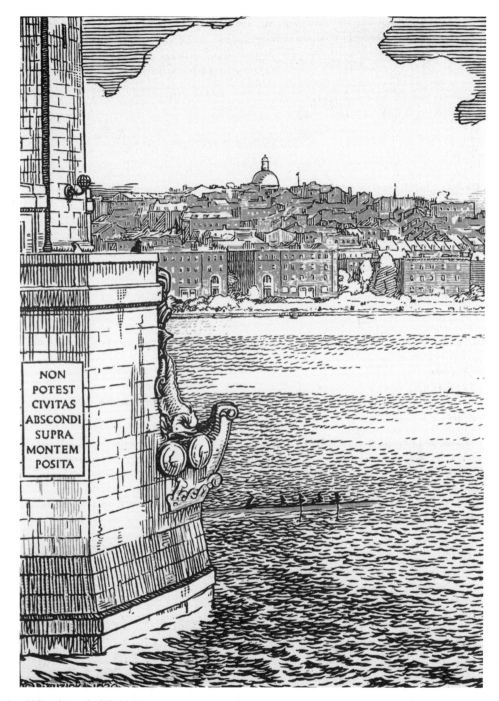

NON
POTEST
CIVITAS
ABSCONDI
SUPRA
MONTEM
POSITA

John Winthrop's Vision

Even today, Bostonians adopt Winthop's vision as their own. Boston sometimes calls itself the "Hub of the Universe" or the "Athens of America." Such elevated opinions of the city are directly descended from John Winthrop. In this 1920 woodcut with a view of Beacon Hill from a pier under the Longfellow Bridge, the artist has inscribed, in Latin, *"Non potest civitas abscondi supra montem posita,"* from Matthew 5:14, "A city that is set on a hill cannot be hid." (R. Ruzicka, private collection.)

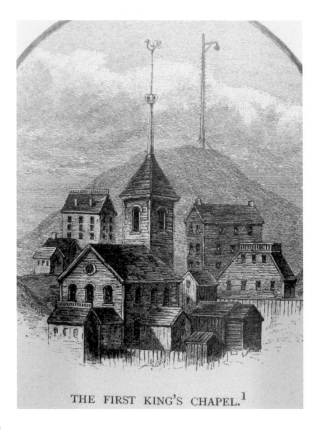

THE FIRST KING'S CHAPEL.[1]

James Freeman

King's Chapel was established on the southeastern slope of Trimountain in 1686 as an Anglican church. Its current building is the second-oldest church in Boston, built about 30 years after Old North Church.

Its congregation, however, is the oldest. The Restoration of the monarchy in England ended Cromwell's Puritan rule, bringing Charles II to the throne in 1660, followed by his younger brother, James II. Seeking to impose order on the motley mix of colonial governments, James revoked Massachusetts's charter in 1686 and sent over his own royal governor, who immediately initiated Anglican worship over Puritan objections. Puritan Boston, while not vanquished, would never again have the power it did at Boston's founding.

In 1689, the Anglicans built a small wooden church, shown here beneath Beacon Hill's beacon. In 1754, they completed a new stone church, albeit without its planned steeple. During the Revolutionary War, many Tory members fled with the British and the communion silver, which has never been found.

After the Revolution, remaining church members followed their young lay reader, James Freeman, into a religion that would be as revolutionary to Christian tradition as the new country was to the old order. This was Unitarianism, meaning God in one, rather than three parts.

King's Chapel embraced the new theology, revised the Anglican Book of Common Prayer to remove Trinitarian references, and ordained Freeman. The architect Charles Bulfinch's father, Thomas, was a senior warden of King's Chapel right after the Revolution.

Several thorny issues remained. King's Chapel needed to establish its independence from the newly organized Episcopal Church of America, successor to the Anglicans, and then began the long, theological competition throughout New England between the Unitarians and renegade Congregational parishes and the orthodox Trinitarian Congregationalists. Things have settled down now.

King's Chapel always attracted Beacon Hill worshipers as the neighborhood grew. In the 1950s, the congregation bought two large houses near the corner of Beacon and Charles Streets to serve as a parish house and a parsonage. (BPL.)

1722 Map of Boston and the Shawmut Peninsula

On the right are small streets along the waterfront and the area now known as the North End. At left in about the middle are Beacon Hill and Boston Common. At the bottom of the map is the Neck, a narrow strip of dry land leading to the mainland. Most of this map is now land, created over the years with fill from the hills. (BPL.)

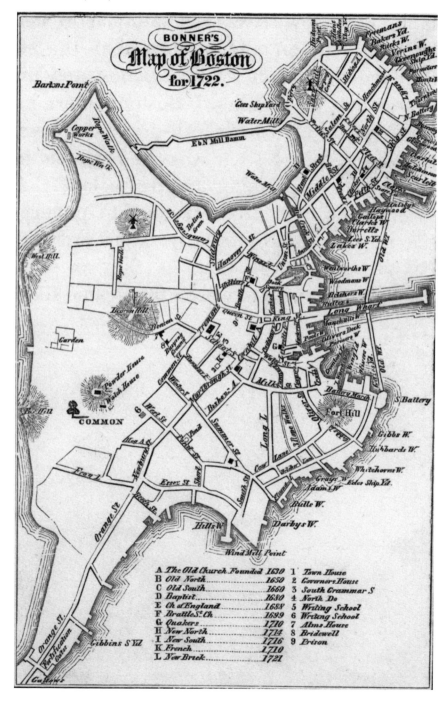

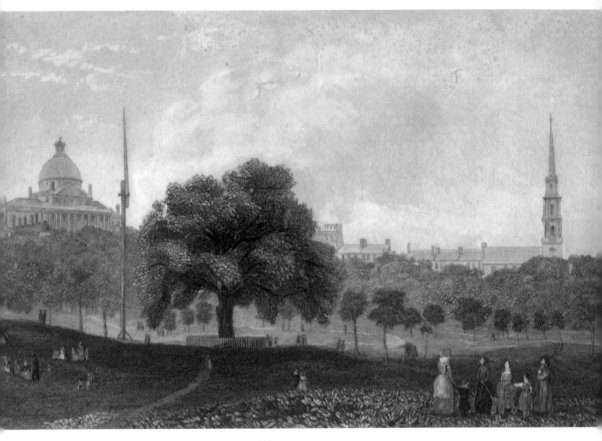

Common Land for a Commonwealth

The Massachusetts State House looks down imperiously on the Boston Common, the nation's oldest public park. The Common has been an important neighbor of Beacon Hill and the heart of Boston since it was founded in 1634. Forty-eight acres in size, it has served as a cow pasture, a camp for Redcoats and World War II soldiers, a place for hanging witches and pirates, a setting for antislavery rallies during the Civil War and antiwar protests during the Viet Nam era, a place for Pope John Paul II to celebrate Mass, a series of Hempfests celebrating marijuana, and a green environment for a busy path on which Beacon Hill and Back Bay residents walk to work. (BPL.)

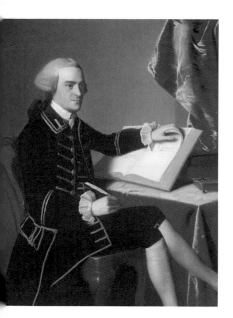 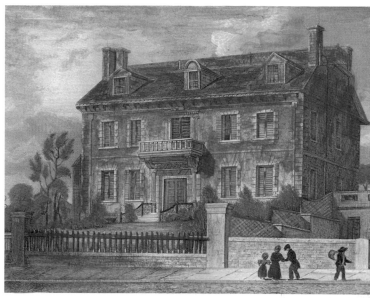

John Hancock

John Hancock (1737–1793) was in his late twenties and had recently inherited his uncle Thomas's business and fortune when his friend and neighbor, John Singleton Copley, painted this portrait of him. Copley portrayed Hancock with his quill in hand, a fine coincidence, since he did not know that Hancock's signature would be the largest and most legible on the Declaration of Independence, and that a "John Hancock" would become a synonym in America for a signature. Hancock was Massachusetts's first governor when it became a part of the newly formed United States.

His handsome Georgian-style house sat on land that John's uncle Thomas had begun accumulating since 1735. It was built of Quincy granite with a front facade of 56 feet. After John died, the town of Boston bought the pasture up the hill from the house and designated it the site for the new State House.

Hancock's house was demolished in 1863 to make room for the expansion of the State House, an act unthinkable today. It galvanized an incipient preservation movement into action. In 1905, William Sumner Appleton used the Hancock house's destruction as the example of what could happen to Paul Revere's house, which was saved. (Left, Museum of Fine Arts, Boston; right, BPL.)

Colonel Middleton

A free black man, Col. George Middleton (1735–1815) served in the Revolutionary War, commanding the Boston-based all-black regiment, the Bucks of America. The Bucks were only a small number of the estimated 5,000 men of African descent who participated in the American War for Independence. John Hancock, governor of Massachusetts after the war, honored Middleton by presenting him with a flag.

The Massachusetts Constitution was intended to end slavery in the commonwealth, and its ratification in 1780 helped accomplish that. Free black men who owned land could vote by 1781. A judicial order in 1783 finally abolished slavery in Massachusetts for good.

Middleton bought land on Beacon Hill after 1770. Some time in the early 1780s, he and friend Louis Glapion, which is sometimes spelled Glampion, built a house as well as stables and other buildings. The charming, small gray house at 5–7 Pinckney Street is what has survived of their property. It is probably the oldest house still standing on Beacon Hill, and it is one of the few built of wood. It continues to be in excellent, original condition. It was built with two doors as a residence and a shop. The current owners use it as a single-family house. (Patrick Boey.)

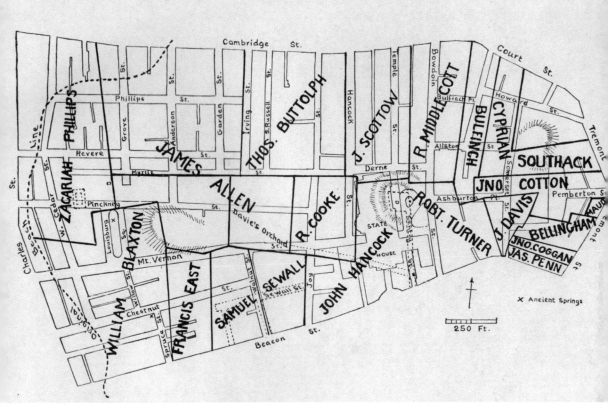

Original Landowners

In his book *Beacon Hill*, Allen Chamberlain provides this map showing the "ancient pasture fence lines as they would appear if rebuilt through the streets and houses of 1925." The author explains that the "heavy lines represent old property boundaries. Original three summits indicated by hachure."

The owners shown are not contemporaneous. William Blaxton, for example, did not own his land at the same time as John Hancock.

Note on the left of this map that the part of the neighborhood called the "flat of the hill" is not filled in. That would happen during the 19th century. On the right side of the map, old streets have disappeared beneath Government Center and the courthouses.

Only the names of Hancock, Bulfinch, and Bellingham have been preserved in names of streets and walkways. Phillips Street exists, but it was named after Boston's first mayor, not its early landowner. (*Beacon Hill: Its Ancient Pastures and Early Mansions*.)

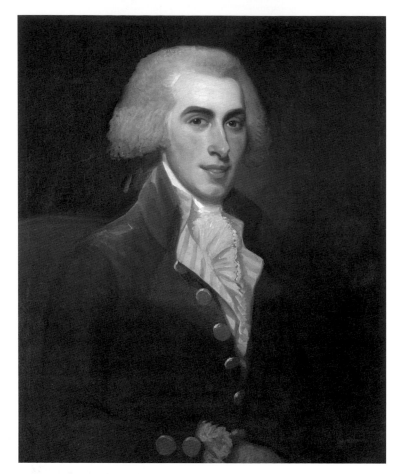

Bulfinch, America's Revolutionary Architect (ABOVE AND OPPOSITE PAGE)
Charles Bulfinch (1763–1844) was well educated at Boston Latin School and Harvard, capping off his learning with a tour of Europe. He immersed himself in the classical architecture of Italy and the Neoclassical architecture of England's finest designers. When he returned, he was ready to begin his practice.

Bulfinch designed grand houses, wharf buildings, and churches. Some remain, in particular three Beacon Hill houses built for businessman, politician, and real estate developer Harrison Gray Otis. His India Wharf was demolished to make room for two bland residential towers now overlooking the waterfront. One church, St. Stephen's, in Boston's North End still stands.

Bulfinch is best known for his capitol buildings. The Massachusetts State House occupies an imposing position overlooking Boston Common. Its design is the standard for capitol buildings all over America. It first had a wooden dome. Then Paul Revere clad it in copper. Finally, it was gilded but was painted black during World War II. It is now gilded again.

Bulfinch designed the capitols of Maine and Connecticut, and he finally became architect of the US Capitol from 1817 to 1829.

Bulfinch was not much of a businessman, losing money in his real estate ventures. He was said to have done an excellent job of chief of police and head of the board of selectmen in the town of Boston.

He left his name in unusual places. A walkway between Bowdoin and Somerset Streets is Bulfinch Place. Cheers was once the Bull and Finch Pub. Shepley Bulfinch is a present-day Boston architecture firm. Charles's son Thomas wrote *Bulfinch's Mythology*. (Above, Imaging Department © President and Fellows of Harvard College; opposite page, *King's Handbook of Boston*.)

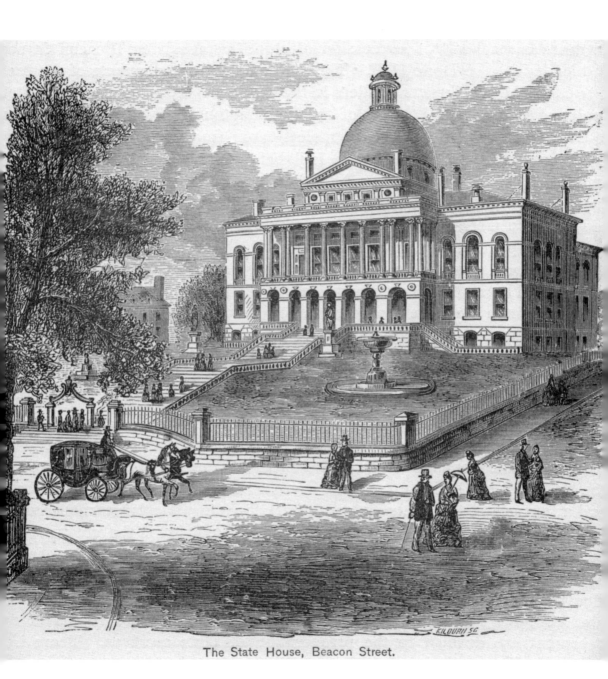

The State House, Beacon Street.

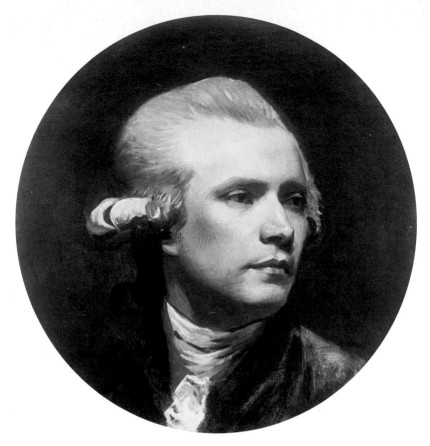

John Singleton Copley

John Singleton Copley (1738–1815) painted patriots, Proprietors, and the action-packed "Watson and the Shark," a scene of Havana Harbor guaranteed to be a spellbinding introduction to the world of art for any child.

Copley's mother sold tobacco on a wharf along Boston Harbor. He grew up without elaborate schooling, but his natural gifts helped him become one of America's most important portraitists.

After achieving substantial wealth through his portraits, Copley bought a farm overlooking the Boston Common, located just west of John Hancock's lavish estate on Beacon Hill. He married the beautiful Susanna Farnham Clarke and then moved into a substantial farmhouse and produced six children.

His wife's family members were Loyalists. In 1774, Copley went alone to Europe to study. As tensions grew in Boston over independence, he sent for his wife and children. They sailed to London in 1776 and did not return to America.

Copley sold his estate to the Mount Vernon Proprietors in the 1790s, but soon felt they had cheated him, since they knew the Massachusetts State House would be built only few hundred yards up Beacon Hill from his land. He was unaware of this development, which, he believed, should have made his land more valuable.

Copley lost a lawsuit he brought to invalidate the sale. His painting suffered from his bad health, and he died in London in debt.

But he lives on in Boston. Copley's paintings hold places of prominence at the Museum of Fine Arts, Boston. His name graces Copley Place, the Fairmont Copley Plaza Hotel, and as the misnomer, "Copley branch," for the Central Library of the Boston Public Library, the first public library to be founded in America, located in Copley Square. (Library of Congress.)

CHAPTER TWO

Early-19th-Century Builders

By the late 1700s, independence was familiar enough to Boston's patriots and their descendants that they felt they could get back to the real business of America, which has always been buying land, building on it, and dreaming of riches. Meanwhile, other Bostonians were starting institutions—churches, libraries, and hospitals—worthy of a new nation and strong enough to serve the city for more than 200 years.

The cornerstone on the Massachusetts State House was laid in 1795, and plans to remove Trimountain's summits incorporated the latest technology, a gravity railroad that carried soil and gravel down to the Charles River where it could be dumped, making new land. An important architect stood ready to design beautiful houses, supported financially by men (and one woman) who had the wherewithal to make it happen.

So in 1796, Harrison Gray Otis, Charles Bulfinch, and other men of wealth and distinction formed the Mount Vernon Proprietors to turn 30 acres of land on the south slope of Beacon Hill into a real estate development filled with the McMansions of their day. Mrs. James Swan (Hepzibah) soon joined them. They acquired land from the artist John Singleton Copley and other owners, laid out streets, and advertised lots for fine houses to be built in the Federal style. Copley, who had moved permanently to England by then, thought the Proprietors had hoodwinked him since he believed they had hidden the State House's imminent construction when they bought his property. The matter went to court, but the Proprietors prevailed.

The development project moved in fits and starts, hampered by economic downturns, changing plans, and the War of 1812. At first, the Proprietors intended to build freestanding mansions surrounded by beautiful gardens as Harrison Gray Otis managed to do with his Mount Vernon Street house, which still stands. But those plans were shelved when the developers realized that row houses would be easier to sell and more profitable.

Grand houses were built and sometimes demolished and replaced with other grand houses. Between 1814 and the 1840s, householders, architects, and developers raised brick row houses along Beacon, Chestnut, Mount Vernon, and Pinckney Streets, smaller than the Proprietors had envisioned, but ample nevertheless. Gradually, the later houses were constructed in the Greek Revival style, as were buildings all over the nation, paying tribute to that ancient democracy that was seen as the model for the young United States.

Each house had to have its own well until 1848. It was then that city fathers built a dam, forming Lake Cochituate west of the city, and ran its water about 20 miles by aqueduct into Boston. This reservoir served Bostonians as their public water supply for 104 years.

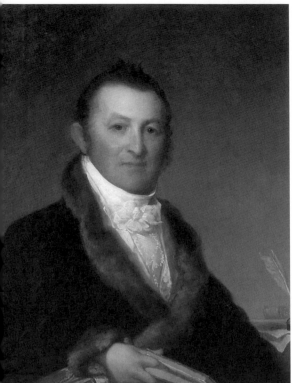

Harrison Gray and Sally Foster Otis

Harrison Gray Otis was a member of a renowned Boston family, a graduate of Harvard, a man of wealth, a practitioner of the law, the third mayor of Boston, a member of Congress, and a friend of John Adams. He married the lovely Sally Foster; they had 11 children.

His importance on Beacon Hill was that he was a builder of houses and a developer of real estate. His three houses, all designed by Bulfinch, still stand. The locations of these houses provide a hint about the rise and fall of Boston neighborhoods.

The first Harrison Gray Otis house, located at 141 Cambridge Street, was finished in 1796 in the Federal style on what was then prestigious Bowdoin Square. It is now the headquarters of Historic New England, which preserves historic properties and decorative items. This house is the only Otis house open to the public. (Both HNE.)

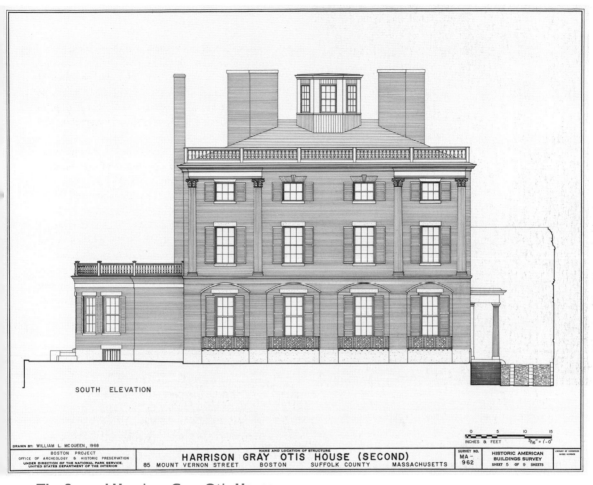

SOUTH ELEVATION

DRAWN BY: WILLIAM L. MC QUEEN, 1968

BOSTON PROJECT
OFFICE OF ARCHEOLOGY & HISTORIC PRESERVATION
UNDER DIRECTION OF THE NATIONAL PARK SERVICE,
UNITED STATES DEPARTMENT OF THE INTERIOR

NAME AND LOCATION OF STRUCTURE
HARRISON GRAY OTIS HOUSE (SECOND)
85 MOUNT VERNON STREET BOSTON SUFFOLK COUNTY MASSACHUSETTS

SURVEY NO.
MA-962

HISTORIC AMERICAN
BUILDINGS SURVEY
SHEET 5 OF 9 SHEETS

The Second Harrison Gray Otis House

As Bowdoin Square changed from residential to commercial uses, perhaps hastened by Otis's move, he built his second house on Mount Vernon Street, originally called Olive Street. He and his partners, the Mount Vernon Proprietors, were luring the era's titans of industry with Beacon Hill's relatively bucolic location and its proximity to the Massachusetts State House, not to mention the late John Hancock's mansion, which gave the new neighborhood the right tone.

The Proprietors planned large houses surrounded by lush gardens, which was what Otis built for himself. But it is now the only freestanding house on Beacon Hill. This second Otis house is in private hands.

The third Otis house was built in 1806 on Beacon Street, where houses could take advantage of the view over the Boston Common. Otis lived here until his death in 1848. The American Meteorological Society now occupies it. (Library of Congress.)

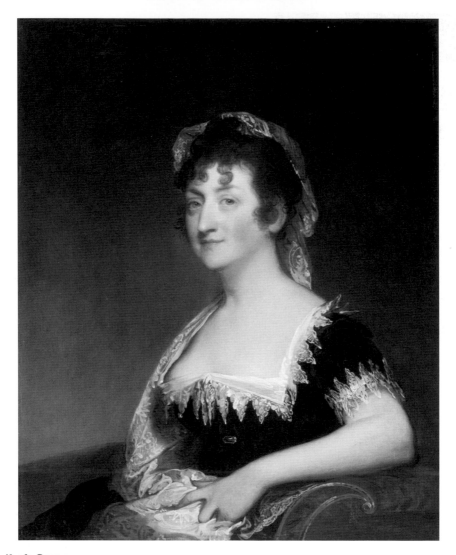

Hepzibah Swan

Hepzibah (Clarke) Swan (1757–1825) was the only woman among the Mount Vernon Proprietors. Perhaps she would not have broken that era's version of the glass ceiling had her husband been around.

James Swan (1754–1830) threw tea in the harbor with the Boston Tea Party, fought at the Battle of Bunker Hill, and aided the young American republic by buying and selling its debt. He and Hepzibah seemed to have little reason to live together. He made and lost fortunes and left for France in the late 1700s, where he was eventually imprisoned for debt and died.

Meanwhile, Hepzibah had probably taken as a lover Revolutionary War general Henry Jackson, who is buried with her in the family plot in the Forest Hill Cemetery in the Jamaica Plain neighborhood of Boston. She was also providing for the Swan daughters, building for them three fine houses on upper Chestnut Street, designed by Charles Bulfinch, and throwing in new stables behind on Mount Vernon Street. The stables have been converted into pleasant houses and famously, by deed, can never be raised more than their 13-foot original height. Hepzibah built 16 Chestnut Street for herself but preferred her country estate in Dorchester.

Gilbert Stuart painted Hepzibah. Unlike his portrait of George Washington, he finished her painting. (Museum of Fine Arts, Boston.)

Asher Benjamin

This early architect had an impact on American house design through his pattern books, which instructed builders how to follow the Federal and, later, the Greek Revival styles. The Boston Athenaeum has the original books.

Benjamin styled himself as a carpenter, but by studying the designs of Bulfinch and paying attention to master builders he worked for, he quickly moved from carving Doric capitals to designing buildings.

Benjamin, born in 1773, was still a young man when he designed such iconic Beacon Hill buildings as the African Meeting House, the Beacon Street home of William Hickling Prescott, and the Charles Street Meeting House, pictured.

He also designed several smaller houses on the hill, and today, those home owners are respectful of Benjamin's original design. When one owner restored her house, she decided not to install air-conditioning since it would destroy too many original plaster walls. Some owners say that the original plaster confers a soft resonance in a house that drywall cannot match. (Above, Historic Deerfield, Inc.; below, R. Ruzicka, private collection.)

John Collins Warren

Dr. John Collins Warren (1778–1856) assisted his father, Dr. John Warren (1753–1815), in 1811 in removing the cancerous breast of Nabby Adams Smith, the beloved daughter of John and Abigail Adams, at their house in Quincy, Massachusetts. The Adamses were determined to have the best doctors they could find to save Nabby. Who could be better than the Warrens, the elder of whom was a founder of the Harvard Medical School? Nabby stoically endured the surgery, performed without anesthesia, of course, but died anyway within two years.

The same year the doctors operated on Nabby, the younger Dr. Warren cofounded Massachusetts General Hospital. In 1846, after an initial skepticism, he helped bring anesthesia by means of ether inhalation to grateful patients.

Such founders must have known that not all ventures in a young country succeed. Nevertheless, the founders of Massachusetts General Hospital (MGH) aimed high. They situated their hospital at the foot of the north slope of Beacon Hill and procured Charles Bulfinch to design it. At first, all services were for the poor and free.

Richer folk paid for the services of doctors who made house calls. During the first half of the 19th century, doctors ran 20 or more private hospitals on Beacon Hill, according to Dr. James H. Herndon, who is at work on a book about the history of orthopedics.

MGH today is the largest nongovernmental employer in Boston. It conducts the largest hospital-based research program in the country. With 950 beds, it is the largest hospital in New England. It is convenient for residents of Beacon Hill, who have to walk only a few minutes down the hill for their checkups. (MGH.)

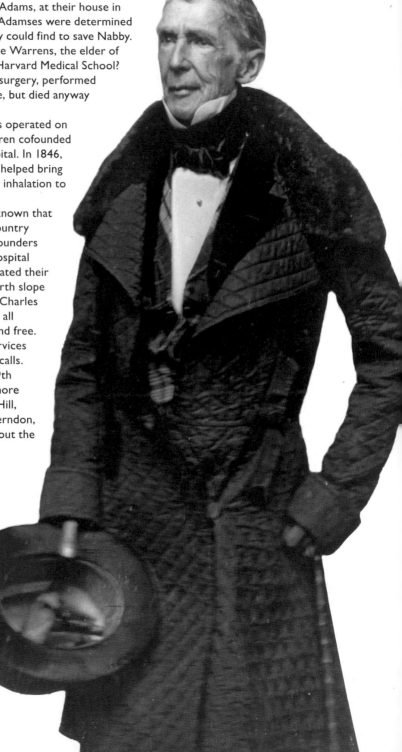

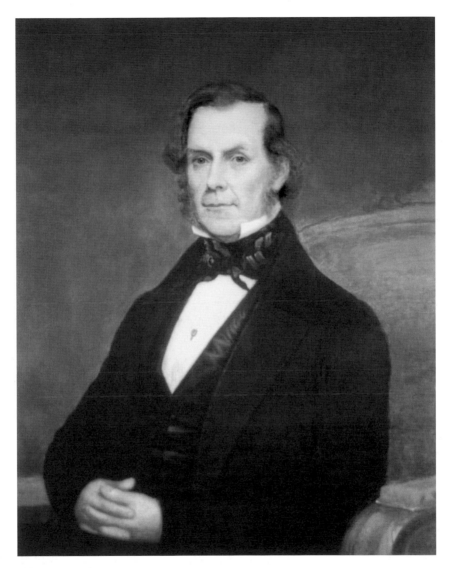

John Jeffries

Dr. John Jeffries (1796–1876) and his colleague Dr. Edward Reynolds set up their first infirmary, treating poor patients with eye diseases, infections, and trauma, in old Scollay Square in 1824. Jeffries came from a medical family. His father was said to have been the doctor who identified the body of his friend Dr. Joseph Warren after the Battle of Bunker Hill.

The doctors grew out of their first quarters quickly. They renamed their hospital the Massachusetts Charitable Eye and Ear Infirmary in 1827, and eventually, they built a brick hospital on filled land in the northwest corner of the Beacon Hill neighborhood. In the early 1900s, the infirmary expanded again to a large building farther down Charles Street, and the doctors built a nurses' residence on the site of the old hospital. In the 1970s, it expanded again.

The nurses' residence has been renovated and is now a small, affordable hotel called the John Jeffries House. Its location overlooking the Charles River at the Charles Street/MGH T station is ideal.

Jeffries's hospital for the poor is now called the Massachusetts Eye and Ear and is affiliated with the Harvard Medical School. It is the world's largest vision and hearing research center. (Abraham Pollen Archives, Massachusetts Eye and Ear Infirmary Libraries.)

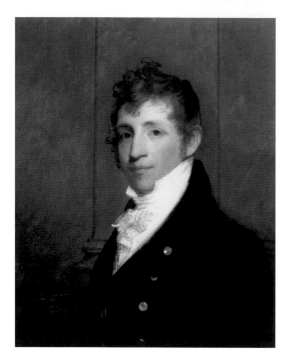

Nathan Appleton

New Hampshire–born Nathan Appleton (1779–1861) attended Dartmouth College but left to work for his brother in Boston. Soon, he had made a fortune as a merchant and mill owner. He and his partners introduced the power loom to New England.

Appleton lived at 54 Beacon Street in a house designed by Asher Benjamin. Later, he moved to 39 Beacon Street, where his daughter Fanny married Henry Wadsworth Longfellow in 1843. Appleton gave the couple Craigie House in Cambridge, where they lived the rest of their lives. Craigie House had been Washington's headquarters during the Siege of Boston, when his troops kept the British confined to the town. The British left Boston on March 17, 1776, and Washington went on to win the war. (Longfellow House, Washington's Headquarters National Historic Site, National Park Service.)

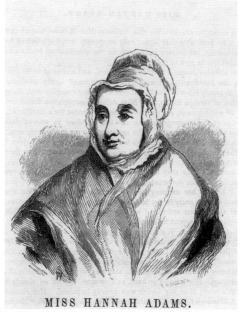

MISS HANNAH ADAMS.

Hannah Adams
and the Boston Athenaeum

In 1807, men of learning created the Boston Athenaeum, a private library on Beacon Street modeled after the Athenaeum and Lyceum of Liverpool, England. William Smith Shaw was named librarian.

Hannah Adams (1755–1831), a religious historian, was an early female member at a time when women were thought not to need such a resource.

The library got a boost in 1809 when Hannah's distant cousin John Quincy Adams temporarily deposited his collection of 5,000 volumes with the Athenaeum while he was the US ambassador to Russia. Its art gallery became the basis for the Museum of Fine Arts, Boston. (Boston Athenaeum.)

William Hickling Prescott

From its earliest beginnings, Beacon Hill attracted men and women who were interested in history, literature, and the arts. Historian William Hickling Prescott (1796–1859) was such a man.

Prescott was born into a much-admired family. His paternal grandfather, Col. William Prescott, had led 1,000 men to meet the British in what became known as the Battle of Bunker Hill. Although the Americans technically lost the battle, they put up such a fight that both sides understood that the colonial army would be a match for the British.

His family was wealthy. He could take his time deciding what his life's work would be. He had an excellent memory, which would come in handy. He had a satisfying domestic life with his wife, Susan Amory, their four children, and many friends.

But he had disadvantages. He had an affliction of involuntary laughter, according to his biographer George Ticknor. This must have disconcerted new acquaintances. Worse, while a student at Harvard, he was hit in the eye with a piece of bread and blinded. His other eye eventually became inflamed, and e struggled with poor sight all his life.

Nevertheless, he set his mind to serious study and learned several languages, concentrating on Spanish. He ordered books from Spain and set to work writing histories. The first was *The Reign of Ferdinand and Isabella*. He went on to write about the conquest of Mexico and Peru. He had help from young men who acted as secretaries and read to him. Eventually, he used an invention called a noctograph to write. His books continue to be influential. He is recognized as the first American historian to use original sources and apply rigorous academic discipline to his writings.

As steeped as he was in Spanish history and language, he never visited Spain, Mexico, or Peru. His Beacon Street home is now the Headquarters House of the National Society of the Colonial Dames of Massachusetts. (Robert Devens.)

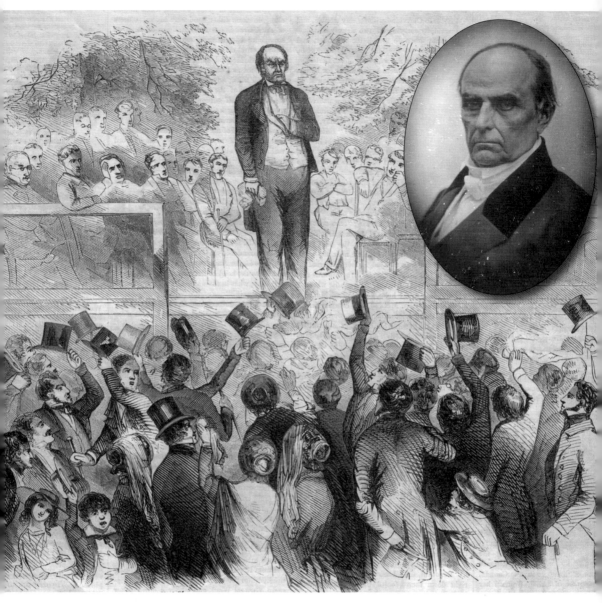

Daniel Webster

Daniel Webster (1782–1852) was a New Hampshire congressman who moved to Beacon Hill in 1817 to practice law. He needed the money.

He had gained a reputation as a powerful orator. As a lawyer, he would walk across the Boston Common to his work, just as Beacon Hill lawyers do today.

Webster went back to Congress in 1822, this time from Massachusetts. He was a senator, ran unsuccessfully for president, and served as secretary of state twice. Abolitionists complained about his compromises over slavery.

Webster's likenesses show a gruff man. But the crowd, in this image on Boston Common, loved him. (Above, HNE; below, *Gleason's Pictorial Drawing Room Companion*.)

William Ellery Channing

The Rev. William Ellery Channing (1780–1842) lived at 83 Mount Vernon Street, where he rested before going out to promote Unitarianism, which was dividing Boston's religious folk. He was the pastor of the Federal Street Church from 1803 until his death. There, he reoriented his Congregational flock toward Unitarianism and founded the American Unitarian Association, thus annoying traditionalists. But some saw Unitarianism as a natural outgrowth of their religion after the revolution. Church members eventually moved their worship to the Back Bay where they built the Arlington Street Church. (BPL.)

Lyman Beecher

Lyman Beecher (1775–1863) was the father of Harriet Beecher Stowe, author of *Uncle Tom's Cabin*, but Bostonians knew him for his opposition to Catholicism, Unitarianism, and alcohol. He was the pastor of the Congregationalists, who, in 1831, built an English Gothic Revival–style church on Bowdoin Street designed by Solomon Willard. The new building was not enough to keep Beecher. He soon moved to Cincinnati.

The Church of the Advent occupied the church between 1863 and 1883, and then, it became a mission church under the auspices of the monastic order of the Society of St. John the Evangelist. (Library of Congress.)

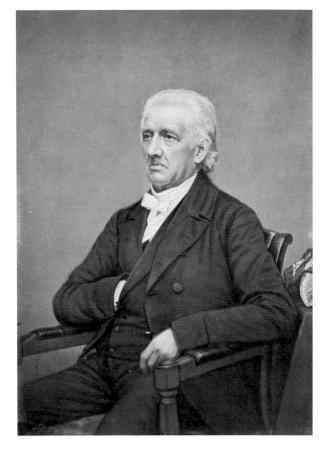

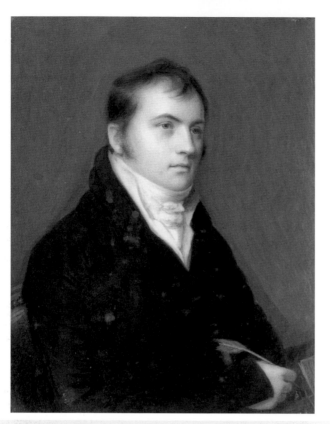

Cornelius Coolidge

Housewright and architect Cornelius Coolidge was responsible for designing and building more houses on Beacon Hill than any other single person, with as many as 50. He worked from 1810 until 1838 in both the late Federal style as well as the Greek Revival style. (Rosenberg Library, Galveston, Texas.)

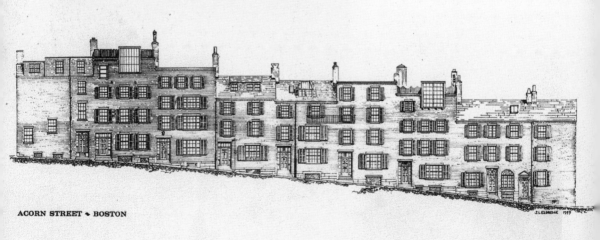

ACORN STREET ◆ BOSTON

Acorn Street

In this line drawing, architect Joseph L. Eldredge, FAIA, a one-time resident of Acorn Street, depicts how the street would look if a viewer could see the facades of these small, early-19th-century houses from a distance. Acorn Street is narrow, paved with cobblestones, and impossible to see all at one time. Coachmen, servants, and workmen lived in these houses when they were built. Many are only one room wide and one room deep. (Joseph L. Eldredge, FAIA.)

Chester Harding

Artist Chester Harding (1792–1866) set up his studio on Beacon Street where he would be near the merchants and mill owners who needed fine portraits of themselves and their family members.

He had started adult life as a traveling salesman, cabinetmaker, tavern keeper, musician, and sign painter. His wife finally taught him to read.

He moved around, living in Massachusetts, Pennsylvania, Kentucky, Missouri, London, and Boston again. Gregarious and kind, he became popular with refined society, despite his rough ways. He died on his way to a fishing trip on Cape Cod.

The Boston Bar Association occupies the building in which his studio was located. (Library of Congress.)

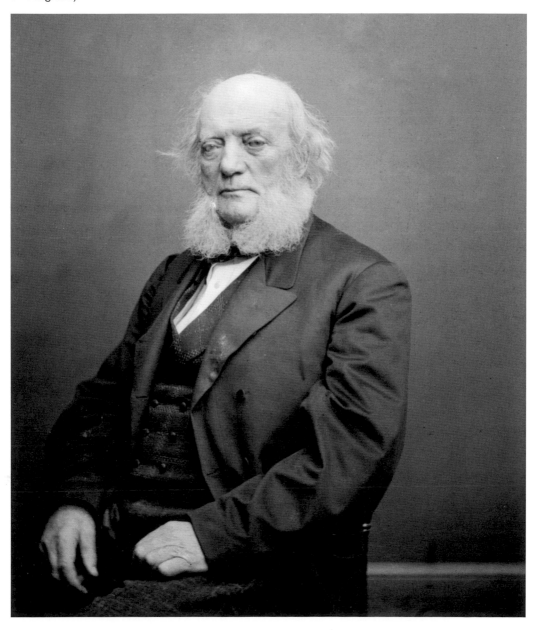

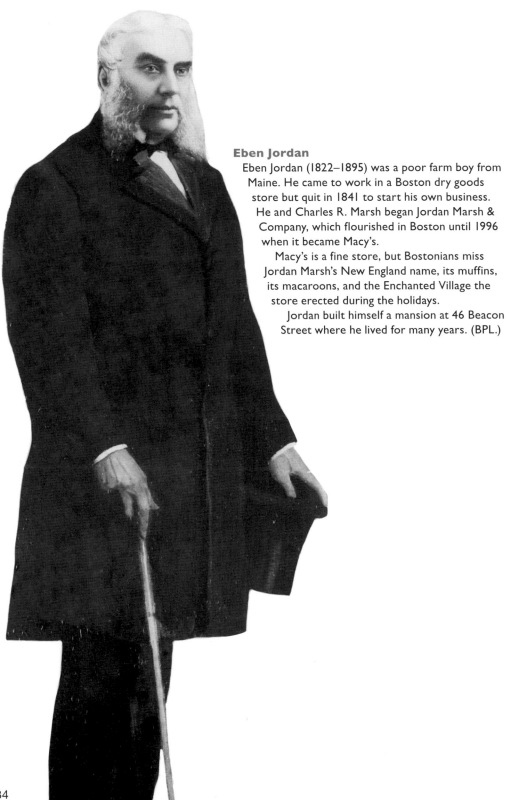

Eben Jordan

Eben Jordan (1822–1895) was a poor farm boy from Maine. He came to work in a Boston dry goods store but quit in 1841 to start his own business. He and Charles R. Marsh began Jordan Marsh & Company, which flourished in Boston until 1996 when it became Macy's.

Macy's is a fine store, but Bostonians miss Jordan Marsh's New England name, its muffins, its macaroons, and the Enchanted Village the store erected during the holidays.

Jordan built himself a mansion at 46 Beacon Street where he lived for many years. (BPL.)

Richard Henry Dana Jr.

Richard Henry Dana Jr. (1815–1882) grew up on Chestnut Street. He was the author of *Two Years Before the Mast*, a memoir about his experience as an ordinary sailor rounding Cape Horn and plying the California coast. He had left Harvard and gone to sea, partly to improve his failing eyesight, caused by a bout with measles. Those two years taught him about the hardships sailors endured and made him a lifelong advocate for the less fortunate.

When he returned to Boston, Dana finished his studies in law. He was an ardent antislavery activist, defending the fugitive slave Shadrach Minkins in 1851.

He was a founder of the Church of the Advent in 1844.

The Church of the Advent's origin was based in the Oxford Movement, an effort by British academics to persuade Anglican congregants to return to their Catholic heritage, traditional doctrines and liturgy, and the pomp and circumstance worthy of an ancient religion.

The "high church" stance did not sit well with many New England Episcopalians, who had been influenced by Puritan practices even as they had created the American version of the Church of England. So Dana and others formed their own parish, holding the first service on Merrimac Street, just north of Beacon Hill.

In addition to a more Catholic form of worship, the Advent had another claim to fame.

The custom in Episcopal churches was to charge rent for pews or sell them. The poor could not participate. The Advent's founders intended to welcome all worshipers for free. In the end, the founders sold shares at $25 each and 26 pews, leaving room for 256 free seats.

Richard Henry Dana Jr. served as a member of the corporation governing the church until his death. His father also served on the corporation, and his sister Charlotte was active in music matters.

The Advent completed its Gothic Revival building at the corner of Brimmer and Mount Vernon streets in 1888. Within its tower is a peal of change-ringing bells pulled in mathematical sequence by volunteers every Sunday. All Bostonians enjoy those bells on the Fourth of July, when they ring out in joyous accompaniment to the *1812 Overture,* performed by the Boston Pops at the Hatch Shell a few hundred feet away. (National Portrait Gallery, Smithsonian Institution/Art Resource, New York.)

The Murder of Dr. Parkman

Dr. George Parkman (1790–1849) was a quiet man with great wealth in property. He lived with his wife and two children in a house on Walnut Street and helped found McLean Asylum for the Insane, now known as McLean Hospital, in Belmont.

He was out collecting rent on his properties in the West End near Massachusetts General Hospital when he disappeared. After several days, his dismembered, partially burned body was found in a pit under Dr. John Webster's laboratory at the Harvard Medical School, where Webster was a chemistry professor. Parkman apparently had loaned Webster money, but Webster could not pay him back. This fact provided a motive for the killing, and Webster was arrested.

All of Boston and Cambridge were horrified. They closely followed Parkman's disappearance and the revelation that he had been murdered. It was doubly horrifying when they realized Webster, a man they all knew, was the likely murderer. After all, he was related to many Beacon Hillers and was married to Harriet Hickling, the noted historian William Hickling Prescott's aunt, the half sister of his mother.

The trial was a sensation. Webster was convicted and hanged. The story still is told in the neighborhood, and every once in awhile some institution mounts an exhibit and tells the story all over again.

While there is no happy ending, there are endings. Parkman's son George Francis, who went to live at 33 Beacon Street after his father's murder, died in 1908 and left that house to the City of Boston. It is a beautiful house and is now used as a guesthouse and entertainment space by the mayors of Boston. Former mayor Thomas Menino lived in it when he was recuperating from a hospital stay in 2013. (MGH.)

CHAPTER THREE

Abolitionists and Authors

By the 1840s, Beacon Hill was largely built up. Shipping magnates, mill owners, and speculators had built substantial houses for their families or as investments. Oliver Wendell Holmes later dubbed these people Brahmins, referring to an upper-class Bostonian who lived a cultured life of relative simplicity, more in tune with Indian ascetics than with the wealthy in other American cities.

Louisburg Square had been laid out, and all but three houses flanking it had been built. Many of Boston's enduring institutions had been created.

The Charles River had been filled in to create Charles Street, and some houses and stables now occupied the flat of the hill. Charles Street's most imposing structure was Asher Benjamin's 1807 Third Baptist Church. More than a century would pass before it would become known as the Charles Street Meeting House.

The north slope had been frequented by rough sorts and gained the nickname of "Mount Whoredom." In 1823, Mayor Josiah Quincy took matters into his own hands and cleaned it up. The builders here were typically individuals, not a real estate syndicate like the Mount Vernon Proprietors, so the north slope grew more organically, with pathways and lanes springing up between the houses occupied by mechanics, seamen, and shopkeepers.

A growing community of free African Americans was part of the north slope population. In 1835, they founded a public school for black children, the first in the nation. The school complemented the African Meeting House, the oldest African American church (1806) that survives.

Within the African American community were leaders in the Abolitionist movement, but objection to slavery was not confined to blacks. Many white residents were also antislavery, including Charles Sumner and Julia Ward Howe.

Slavery was not the only concern. Boston needed more land and had to devise a solution to Back Bay's odiferous tidal flats. In 1837, amateur horticulturalists created a botanical garden next to the tidal flats at the foot of Boston Common, establishing the prototype of today's Public Garden. Twenty years later, the legislature authorized the filling of those noxious tidelands.

Wealthy Beacon Hill families began leaving for the new, fashionable Back Bay—no longer a bay— where they could build houses larger and more ornate than those on the hill.

Beacon Hill always attracted intellectuals. The departure to the Back Bay left room for less affluent literary and artistic folk to move in. Louisa May Alcott spent winters on the hill. Publishers found life in the neighborhood congenial. Oliver Wendell Holmes chose a house on Charles Street.

As the 19th century ended, Beacon Hill was in decline. Rooming houses supplanted single-family housing. The north slope's owners found they could make money rebuilding their small houses into flat-roof tenements, housing multiple immigrant families arriving from Southern and Eastern Europe in great numbers.

But this density brought community, not conflict. The proximity to the city's business districts and its educational and medical institutions lent practicality, not problems. So though Beacon Hill floundered, it never failed.

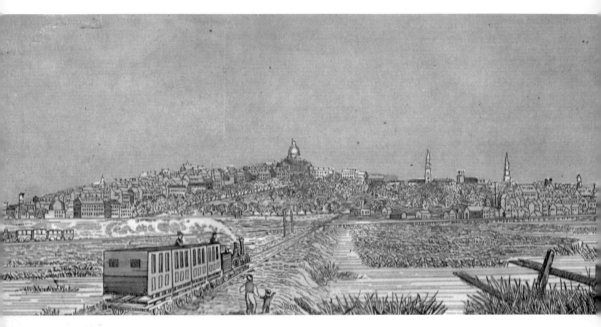

Beacon Hill from the West

This wood engraving shows Beacon Hill in about 1840 as a neighborhood filled with handsome row houses. The Back Bay is still a marsh with a causeway running across it, carrying the Worcester & Providence Railroad. Within 20 years, the Back Bay would be filled, houses would be built, and some Beacon Hill residents would move to that fashionable and newer district. (Barber's Historical Collection, private collection.)

Jenny Lind and Samuel Gray Ward

Jenny Lind, "the Swedish Nightingale," must be the only person whose name adorns both a sewing machine and a style of bed. She gave concerts in Boston several times beginning in 1827 and created a sensation wherever she performed. She married her accompanist, Otto Goldschmidt, on February 5, 1852, at 20 Louisburg Square, much to the delight of all the neighbors since.

The owners of 20 Louisburg Square were Ann and Samuel Gray Ward. Ward was a occasional poet and the banker who handled America's purchase of Alaska. At the time of Lind's marriage, he was the American representative for Barings Brothers, the bank that oversaw Jenny Lind's growing fortune and also had helped, a half century earlier, with the United States' purchase of the Louisiana Territory. The soprano and her new husband left America in May 1952 and moved to England where she died in 1887. (Left, BPL; right, Imaging Department © President and Fellows of Harvard College.)

Sen. Charles Sumner

Charles Sumner was a frequent guest at the tables of his Beacon Hill neighbors. He was born on Irving Street and, later, occupied a Federal-style house on Hancock Street for many years. He interrupted his stay in the neighborhood only for trips to Europe and Washington, DC.

He and Longfellow squired Charles Dickens around Boston when the English author came to visit. Since he was fervently antislavery, Sumner spent much time with Boston's abolitionists. Those were the happier days.

In 1856, South Carolina representative Preston Brooks, angered by Sumner's abolitionist oratory, beat Sumner almost to death with his cane on the floor of the Senate. The drawing below, perhaps by Winslow Homer, shows Brooks, on the right, raising his cane over an unsuspecting Sumner. The man on the left with the cane is South Carolina representative Lawrence M. Keitt, threatening onlookers so they will not intervene.

Sumner never fully recovered, and the beating inflamed Bostonians. He came back to Boston a few months after the beating to a parade in his honor and a cheering crowd. As the parade made its way up Beacon Street, his friend William Hickling Prescott waved to him and then penned a note to welcome him home. (Both, Library of Congress.)

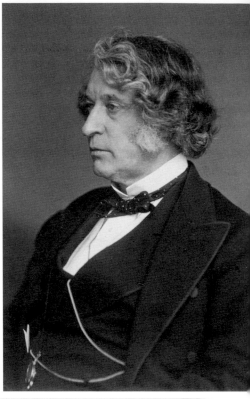

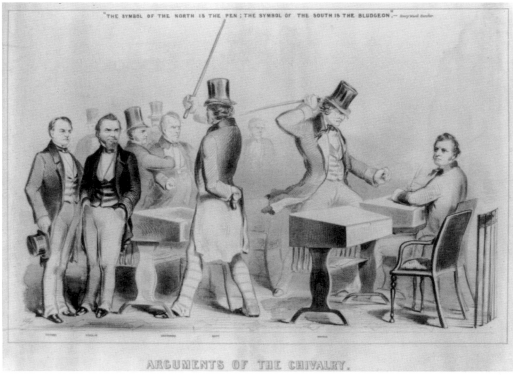

"THE SYMBOL OF THE NORTH IS THE PEN; THE SYMBOL OF THE SOUTH IS THE BLUDGEON."

ARGUMENTS OF THE CHIVALRY.

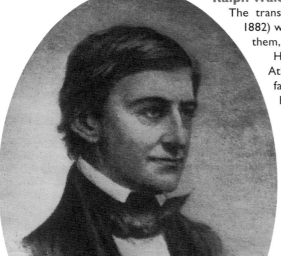

Ralph Waldo Emerson

The transcendentalist Ralph Waldo Emerson (1803–1882) was a friend of Beacon Hill's literary folks. Like them, he was also an abolitionist.

His father was a founder of the Boston Athenaeum. His widowed mother moved the family to Beacon Hill so the youth could be near Boston Latin School.

Emerson attended the Harvard Divinity School. He preached at Boston's Second Church but resigned, saying he no longer could tolerate the practice of communion. He believed organized religion prevented people from achieving a pure spiritual life. (BPL.)

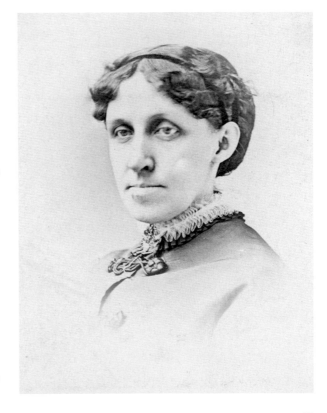

Louisa May Alcott

Louisa May Alcott (1832–1888) was another writer who made her home on Beacon Hill. As a child she played on the Boston Common. As an adult, during winters, she rented houses on Pinckney and Beacon Streets and Louisburg Square, where she and her father lived in declining health. The family would live in Concord, Massachusetts, during the summers.

Louisa's parents were members of the group of transcendentalists that included Ralph Waldo Emerson. Louisa spent time with other writers and wrote pieces for the *Atlantic Monthly*. *Little Women* enabled Louisa to provide for her family, since her father, Bronson, was never up to the task. (HNE.)

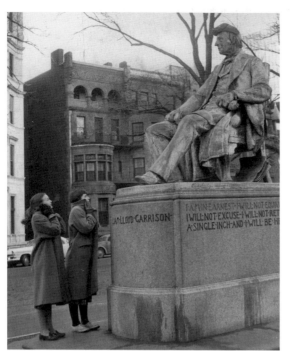

William Lloyd Garrison

William Lloyd Garrison (1805–1879) found Beacon Hill to be fertile ground for attracting abolitionist support. At the African Meeting House, he and 12 other men founded the New England Anti-Slavery Society. It was on Bowdoin Street that Garrison worshipped until he fell out with minister Lyman Beecher over Beecher's insistence that slavery be ended gradually. Garrison also held forth at the Charles Street Meeting House.

His newspaper, the *Liberator*, was published from 1831 until the Civil War's end. He supported women's rights too. Pictured in 1959 are two women identified as Beacon Hill residents Barbara Tardif and Judy Costaire admiring Garrison's statue on the Commonwealth Avenue Mall. (*Boston Herald Traveler* archives, BPL.)

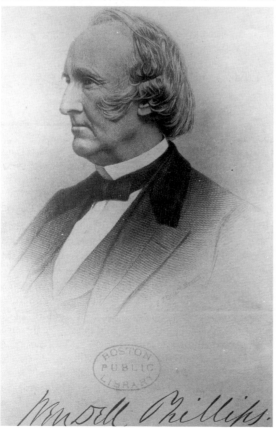

Wendell Phillips

Wendell Phillips (1811–1884), born on Beacon Street, was only 12 years old when his father John, Boston's first mayor, died. He followed him into the law and leadership, but for the abolitionist cause. Phillips and such abolitionist friends as Richard Henry Dana Jr. got into trouble for their advocacy. Phillips was arrested and threatened with harm, and Dana was once bludgeoned by a mob on his way home. Curiously, the abolitionists are remembered today; there must have been some hill residents who were proslavery, but their names have been forgotten. (BPL.)

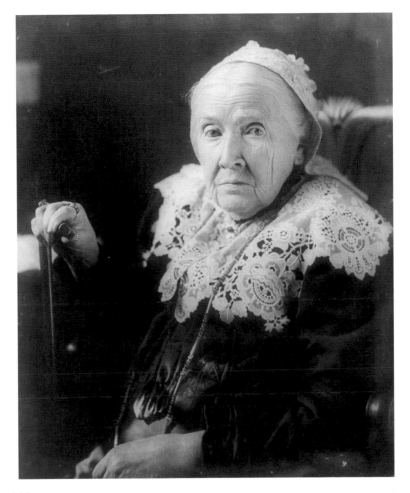

Julia Ward Howe

Julia Ward Howe (1819–1910) and her husband, Samuel Gridley Howe, were members of the group of intellectuals, writers, transcendentalists, and abolitionists who thrived in Boston before and after the Civil War. The words to her *Battle Hymn of the Republic* were first published in the *Atlantic Monthly* in 1862.

The Howes lived in South Boston at the Perkins Institution, founded as a school for the blind by Samuel Gridley Howe. But they also lived periodically on Chestnut Street, at one of the houses Hepzibah Swan built for her daughters. That location would have been more convenient for seeing such friends as Charles Sumner, William Hickling Prescott, and William Ellery Channing. Some believe their houses were stops on the Underground Railroad.

Why Julia would marry Howe, who was 18 years older than she, is puzzling. She was well read and wanted a career in letters, and he was an opinionated, controlling man who believed that women should not work outside the home. Widely admired by the public, he seems to have behaved wretchedly to his wife. When they married in 1843, he assumed control of her income, and he lost much of it through bad investments. Julia published anonymously at first, burdened with her husband's disapproval. She was often depressed, they separated at least once, and when he died in 1876, she is reported to have written, "Start my new life today."

And she did. While she had already gained fame and admiration for her works, she was busier than ever in the last half of her long life. She worked for women's suffrage and prison reform and wrote novels, travel books, and children's literature. (Library of Congress.)

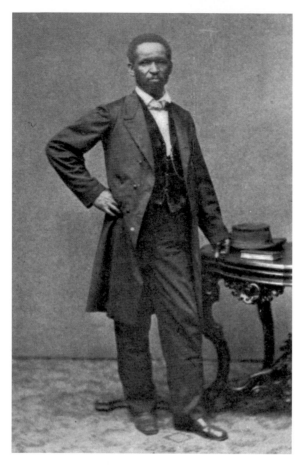

Lewis Hayden

Beacon Hill's north slope, unlike its south slope, grew up without real estate developers to straighten out its quirky walkways and hidden passages. Those unpredictable little lanes are seen as charming now and serve as the setting for the Beacon Hill Art Walk on the first Sunday in June, when 100 artists or more display their work.

In the 1850s, those passageways gave the Underground Railroad protection from the slave catchers who challenged those who helped enslaved men and women escape.

Lewis Hayden (1811–1889) and his second wife, Harriet, were foremost among those hiding runaway slaves. It helped that Harriet ran a boardinghouse on Phillips Street where escapees could reputedly hide in a secret tunnel. Lewis had a clothing store on Cambridge Street, where he could help men and women who came to Boston without much more than the clothes on their back.

The fact that the Haydens were able to own a house and a business and help other African Americans was remarkable and certainly not expected, given their origins.

Lewis Hayden was born into slavery in Kentucky in 1811. He was a boy sitting on a fence when the Marquis de Lafayette passed by, so the story goes. Lafayette nodded to him, and Hayden took that nod as evidence of his value as a man, not a slave. He taught himself to read and married Esther Harvey. She and their son were sold to US senator Henry Clay, who later sold them to a faraway owner. Hayden confronted the unsympathetic Clay but would not see his wife and son again.

In 1844, Hayden and his second wife escaped, ending up in abolitionist Boston. He became financially successful and a member of the Boston Vigilance Committee, which rescued such captured fugitives as Shadrach Minkins before they could be returned to the South.

During the Civil War, Hayden recruited black men to serve in the 54th Regiment, and he invited Gov. John Albion Andrew to his house for Thanksgiving dinner. Andrew accepted the invitation, arousing disapproval from some folks. After the war Hayden was elected to the Massachusetts House of Representatives. When Harriet Hayden died in 1893, she left money for a scholarship for African American students at Harvard Medical School. (Houghton Library, Harvard College Library, Harvard University.)

John Albion Andrew

Governor Andrew (1818–1867) was a determined abolitionist, helping fugitive slaves escape, promoting abolitionist candidates for public office, and serving as Massachusetts's governor from 1861 to 1866. When Lincoln, his distant relative, was elected, Governor Andrew predicted that war would follow. He made sure Massachusetts troops were ready, and because of this, the Bay State's soldiers were the first to fight in the Civil War. He lived at 110 Charles Street, a block away from where Oliver Wendell Holmes would settle.

Andrew may have been partly responsible for Julia Ward Howe's *Battle Hymn of the Republic*. He took her, her husband, and Boston abolitionist Rev. James Freeman Clarke to the White House where Julia saw the worry on Lincoln's face. In the carriage ride back to their hotel, they passed encampments where soldiers were singing "John Brown's Body." Clarke suggested to Julia that she write new words to that song, which she did that night.

Andrew showed his mettle by accepting an invitation to Thanksgiving dinner in 1862 from the African American leader Lewis Hayden, who lived on Phillips Street a few blocks away. Not all abolitionists would go so far as to socialize with blacks, but Andrew was determined to promote equality not just to abolish slavery.

When Deval Patrick, Massachusetts's first black governor, took office in 2006, he hung Andrew's portrait on the wall of his office at the State House. (Library of Congress.)

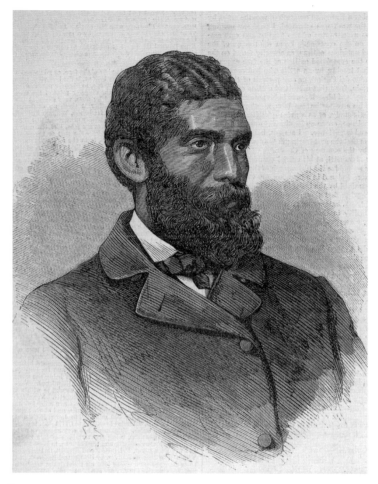

John Sweat Rock

John Sweat Rock's life represents the reach and achievements of the free black community that developed on Beacon Hill's north slope during the 19th century.

Rock was born in New Jersey in 1825. He was a hard worker despite suffering from lifelong health problems. He became a teacher, a dentist, and eventually, a medical doctor and lawyer.

Blacks practiced medicine all over the country, attending medical schools in Scotland and elsewhere in order to be able to serve. Rock trained in America, finally admitted to a Philadelphia medical school, where he was among the first African Americans to earn a degree.

In 1853, Rock moved to Boston where he became the second black man to be admitted to the Massachusetts Medical Society. Practicing both dentistry and medicine, he often cared for fugitive slaves.

He grew increasingly active in the abolitionist cause, making speeches and joining with such other notables as Frederick Douglass at podiums in Boston and farther west.

In 1858, he traveled to France, seeking medical care from some of the best doctors in the world. It was not easy to get there. He was refused a US passport because the Supreme Court had determined that blacks were not citizens. Massachusetts intervened and created its own passport for Rock, and he sailed away. He returned to America just before the Civil War, determined to study law, a profession that might allow him to be of greater use to the abolitionist cause. Aided by Sen. Charles Sumner, his neighbor, he became the first person of color to be admitted to practice before the Supreme Court. He died in 1866 after catching a cold. He was only 41. (BPL.)

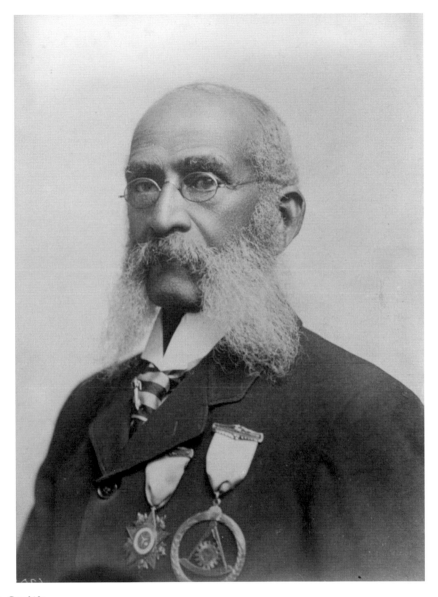

John J. Smith

John J. Smith (1820–1906) was an African American born free in Virginia. Free blacks walked a tough line. On the one hand, they were proud of their freedom. On the other, they had to ensure that their higher status did not denigrate those who were still enslaved.

Smith worked as a barber and read the *Liberator*. In 1848, fearful for his safety and possible illegal enslavement, he left Virginia and ended up, like many young men, in California, futilely searching for gold.

But back he came to the East and set up a barbershop on Beacon Hill that became a center for abolitionist activity. Sen. Charles Sumner, who lived nearby, spent much of his free time at Smith's shop when he was in town.

During the Civil War, Smith moved to Washington, DC, and recruited black men for the 5th Massachusetts Cavalry, the third colored unit formed in the commonwealth during the Civil War. After the war, he was elected to the Massachusetts House of Representatives three times. (MAAH.)

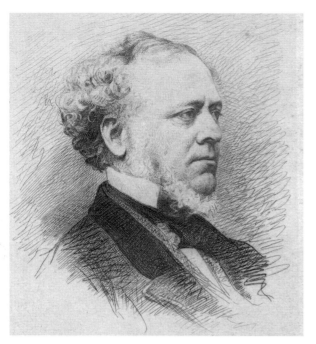

William Ticknor

With all the authors living on Beacon Hill, they found it convenient that their neighbor was a publisher. William Ticknor (1810–1864) founded his company in 1832. A later Beacon Hill resident would save his offices at the Old Corner Bookstore from destruction in the 20th century.

James T. Fields eventually joined the firm. Ticknor and Fields published Dickens, Twain, and Hawthorne as well as the men's Beacon Hill neighbors, Emerson, Holmes, and Lowell. They bought the *Atlantic Monthly* in the late 1850s. Ticknor and Fields merged their publishing house with Henry Oscar Houghton and George Mifflin in the 1880s. The company still operates in Boston, now under the name of Houghton Mifflin Harcourt. (BPL.)

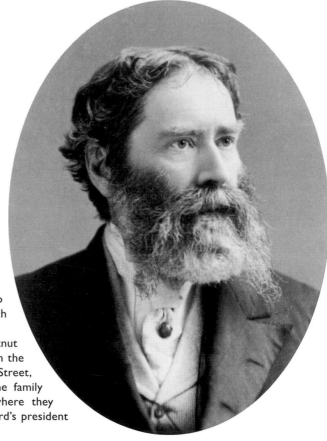

James Russell Lowell

The first editor of the *Atlantic Monthly* was James Russell Lowell (1819–1891), who took on the job in 1857. He was part of the group of literary figures and abolitionists— Oliver Wendell Holmes, Longfellow, Julia Ward Howe, and Ralph Waldo Emerson—who met as the Boston Radical Club on Chestnut Street to discuss literature and opinions, much as Beacon Hill residents still do.

Lowell was raised on Chestnut Street, only a few blocks away from the Old West Church on Cambridge Street, where his father was minister. The family later decamped for Cambridge where they bought the Elmwood estate. Harvard's president lives there now. (HNE.)

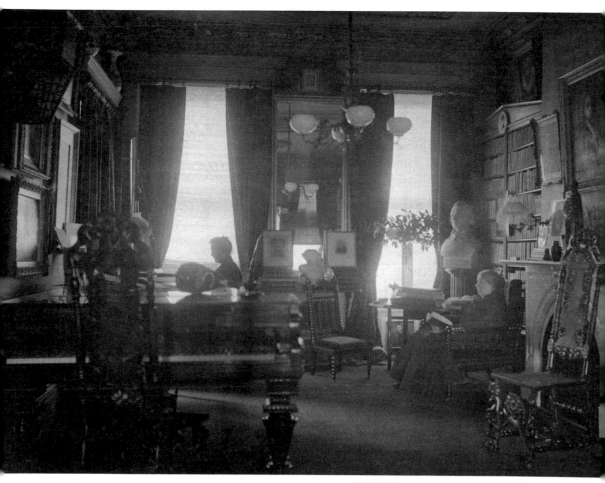

James and Annie Fields

James T. Fields (1817–1881) was another editor of the *Atlantic Monthly*. His publishing house, Ticknor and Fields, bought it in the late 1850s. When its first editor, James Russell Lowell, stepped down in 1861, Fields took over.

Annie Adams Fields, his second wife, was 20 when she married Fields, 17 years her senior, in 1854. She wrote biographies and poems and edited the works of many writers at the *Atlantic Monthly*. The Fieldses entertained a wide group of writers. Annie is seen doing just that in this photograph, where she (at left) and Sarah Orne Jewett enjoy the library in the Fields home at 148 Charles Street. After James Fields's death, Jewett came to live with Annie. Jewett died in 1909, and Annie died in 1915.

The Fields house, like Oliver Wendell Holmes's house, sat on land that bordered the Charles River. The house is gone now, replaced by a garage owned by the Massachusetts Eye and Ear. Annie's large garden remains, hidden from the street, and is enjoyed by residents of the 14 buildings that surround it. (HNE.)

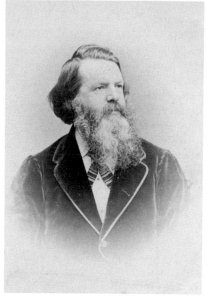

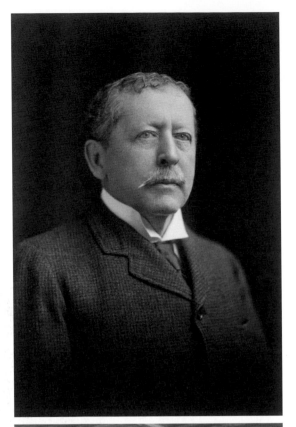

Thomas Bailey Aldrich

The *Atlantic Monthly* attracted many of the nation's literary men. Author Thomas Bailey Aldrich (1836–1907) was another Beacon Hill resident who succumbed, serving at its fourth editor from 1881 to 1890. It was only a short walk across the Boston Common to the magazine's offices. And many of its writers and readers lived on Beacon Hill too. As editor, he could reach them quickly if he needed their comments or new material.

Aldrich must have taken his duties seriously because he moved to Charles Street, across from Annie Fields and Oliver Wendell Holmes. The neighbors often breakfasted together, and entertained visiting authors. (HNE.)

William Dean Howells

In this photograph, William Dean Howells (1837–1920) could be in his library at 16 Louisburg Square or at his house in the Back Bay, where he later moved. Perhaps he is pouring a drink for his friend Mark Twain.

From 1871 to 1881, Howells was the *Atlantic Monthly*'s editor, one of several such editors who lived on Beacon Hill. His most famous book is *The Rise of Silas Lapham*, but his output of novels, magazine articles, poems, essays, and stories was prodigious. His friends were the major authors of the day, partly because he published their works. (Library of Congress.)

Oliver Wendell Holmes

Dr. Oliver Wendell Holmes (1809–1894) lived at 164 Charles Street in the 1860s. It was close to Massachusetts General Hospital and the Harvard Medical School, where he taught. He kept rowboats in his rear garden along the Charles River.

His study at the back of the house had a beautiful view of the river. He often invited James T. Fields, the publisher and his neighbor, to visit in order to enjoy the sunset.

Holmes, pictured at right, was short, handsome, witty, and smart. He was a medical doctor and a Unitarian. His friends were the typical literary and intellectual set in mid-19th-century Boston, represented here by Unitarian minister and fellow author Edward Everett Hale, at left. Holmes is said to have given the *Atlantic Monthly* magazine its name and participated in its founding, contributing essays that were collected into his most famous book, *The Autocrat of the Breakfast Table.*

Holmes's literary contributions overshadow his important medical contributions. He was the first to theorize that women died of puerperal fever in childbirth because the doctor's hands were contaminated with bacteria. Another contribution was his son, Oliver Wendell Homes Jr., a Supreme Court justice.

Words Bostonians use today are due to Holmes. To its citizens, Boston is "the hub," shortened from "Boston State-house is the hub of the solar system." Holmes dubbed Boston's 19th-century industrialists and merchants "Brahmins," thus comparing them to Indian ascetics in their self-discipline, intellect, and cultured lives. (BPL.)

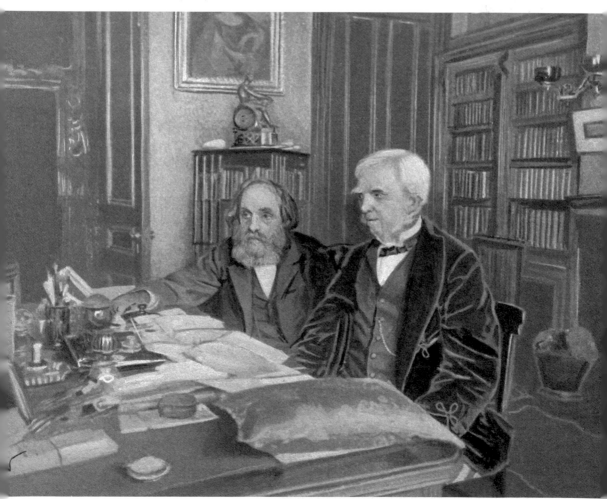

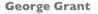

George Grant

George Franklin Grant (1846–1910) was born free in Oswego, New York. He moved to Boston to attend the Harvard School of Dental Medicine, graduating in 1870, the second African American to do so. The next year, he became the school's first African American professor. He lived on Charles Street for about 20 years.

Married three times, once to a daughter of abolitionist and neighbor, John J. Smith, he was widowed twice. He had a knack for invention. He patented a wooden golf tee and a device to assist those with a cleft palate. He died at his country home in Chester, New Hampshire. (Harvard Medical School.)

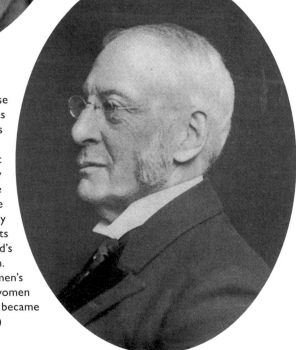

Charles W. Eliot

Charles W. Eliot was born in 1834 in a house on land now occupied by the Massachusetts State House's 1916 addition. He was president of Harvard from 1869 to 1909.

It is hard to exaggerate how important Harvard was to Beacon Hill. An early architect in Harvard Yard was the same Charles Bulfinch who had designed the State House. The neighborhood's literary and professional men and its abolitionists had attended the college, despite Harvard's equivocation on matters North and South.

Although Eliot was no fan of women's education, in 1879, under his tenure, women were admitted to the Harvard Annex. This became Radcliffe in 1894. (King's Chapel archives.)

CHAPTER FOUR

Laying Groundwork in the 20th Century

The first half of the 20th century continued the decline in appeal and property values on Beacon Hill. Rooming houses and tenements did not offer the fine living the Proprietors had envisioned. Two world wars and a depression were no help, either.

The economic stagnation prevailed on Beacon Hill with some ups and downs until the 1980s. But it was not all bad. Affordable rents and proximity to towns where New England's earliest fine furniture makers had lived created an antiques mecca on Charles Street as good as any district in New York. Moreover, this period was a productive time that prompted residents to lay the foundation for the vibrant, engaged neighborhood that would flourish again by the century's end.

The early-1900s residents recognized Beacon Hill's advantages in convenience and beauty. They were civic-minded. They had many interests or a profession in the arts, law, literature, history, and education. They created significant institutions and initiated historic preservation, protective zoning, civic improvements, a satisfying commercial district, and a close community feeling, qualities that are Beacon Hill's strengths today. Authors continued to find the neighborhood appealing.

Farsighted leaders persuaded the legislature in 1903 to pass a bill creating a dam at the mouth of the Charles River and a park along its banks. This new Charles River Esplanade gave Beacon Hill and Back Bay residents space for walking, running, skating, biking, and sunbathing. William Sumner Appleton founded a preservation organization now called Historic New England, which rescued an important house at the foot of Beacon Hill's north slope. Gertrude and Frank Bourne helped found the Beacon Hill Garden Club and the Beacon Hill Association, later to become the Beacon Hill Civic Association. Rose Nichols inherited the house that would later bear her name as a museum. One of her sisters, Margaret, began a tradition of holiday bell ringing, while her other sister, Marian, helped found the new neighborhood association and watched over zoning and wild behavior at bars. A group of ladies sat on the historic bricks to prevent the city from replacing them with more modern concrete.

The Depression and World War II slowed the growth of these organizations and improvements in the neighborhood's quality of life. After the war, Beacon Hill suffered another blow. All over America, urban dwellers followed the siren call of the automobile into the suburbs, abandoning close quarters for freestanding houses and ample yards. Bostonians were no different from residents of other cities in that regard.

But many neighbors hung in, and new people joined them, believing that Beacon Hill's sense of community and history were hard to find elsewhere. The Boston Common and Public Garden provided beauty and a respite from the brick. The convenience of the neighborhood to workplaces, shopping, and recreation could not be beat.

The neighborhood's commitment to history was solidified in 1955 when John Codman successfully led the effort to designate parts of the hill a historic district by state law. Eventually, the entire hill was included.

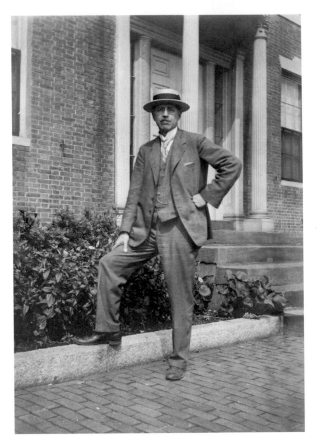

William Sumner Appleton Jr.

William Sumner Appleton Jr. was the founder of the Society for the Preservation of New England Antiquities (SPNEA). He was born in 1874 to an old, well-to-do Boston family, and like most of those sons, he attended Harvard College and made the grand European tour. He was influenced by John Ruskin and William Morris and acquired an interest in early-American architecture and its preservation. One of his first ventures into preservation was working on the Paul Revere House in Boston's North End. His friends knew him as Sumner.

Conveniently for him, much early-American architecture was to be found in New England, and he was determined to save it. He bought his first old house in Newbury, Massachusetts. The 1670 Swett-Ilsley House was no grand mansion, but a modest colonial structure. His work revealed original framing, paneling, and a large fireplace. His restoration was notable for its lack of sentimentality, presuming nothing, but the relying on the evidence in the details he actually found. That was different from some "historic" renovations at the time, which were based on the restorers' imagination and fancy.

Soon after beginning the restoration of the Swett-Ilsley House, he made friends with the families living in two other historic houses in Newbury, the Coffin House and the Spencer-Peirce-Little House. Both families eventually donated their houses to SPNEA.

Appleton began a collection of photographs and other documents that now numbers more than one million items and a collection of household objects and decorative arts that numbers 110,000.

By the time of his death, the society owned 51 historic buildings, including the first Harrison Gray Otis house across Cambridge Street from Beacon Hill.

Appleton died in 1947, but the society has lived on. It changed its name in 2004 to Historic New England, but it continues to preserve the 36 properties it now owns, and it has expanded its mission to include historic 20th-century houses as well as those of antiquity. (HNE.)

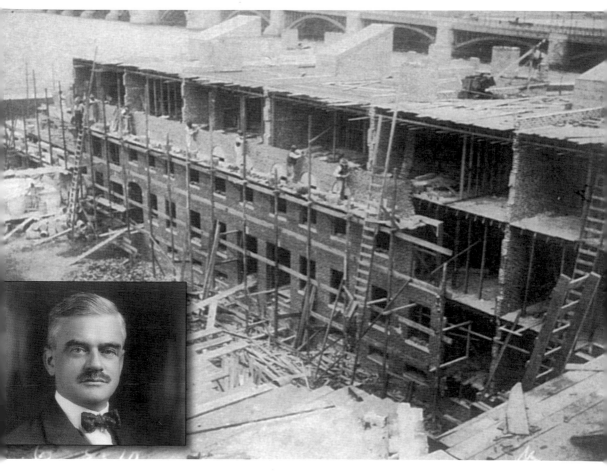

Gerald Street

The Charles River Dam was completed in 1910. The river was no longer subject to tides. The permanent water level encouraged city officials to create more land on the flat of Beacon Hill. William C. Codman Jr. and Gerald G.E. Street formed a real estate firm and proceeded to build houses, many on the filled land.

Street hired architect Frank Bourne to design the U-shaped Charles River Square with 19 brick houses surrounding a long planting bed with roadways on each side. Those on the north side back up to Annie Fields's garden.

Construction began around 1910 and went slowly. "They had a terrible time setting footings or foundations due to that area being filled land," said grandson Earle B. Street. "My grandfather mentioned that he had a case of nervous prostration and medical advice saw him going off to Florida or Cuba to recover."

Street also developed West Hill Place, houses built around a circle that once defined a round gasometer.

Gerald Street finally finished his project. His real estate business became the present-day Street and Company. One photograph shows Charles River Square under construction. The Longfellow Bridge over the Charles River is visible in the background. (Both, Earle B. Street.)

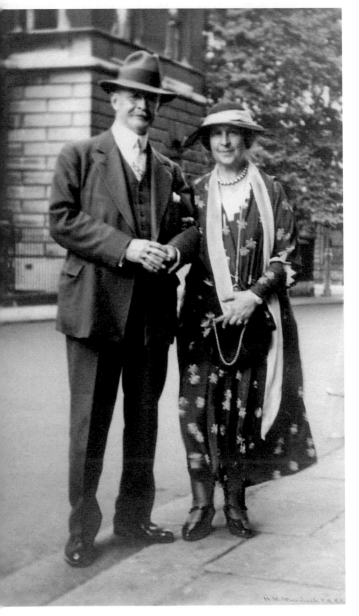

Gertrude and Frank Bourne

Gertrude Beals Bourne (1868–1962) and Frank A. Bourne (1871–1936) were both talented artists, with Gertrude as a watercolorist and Frank as an architect.

The Bournes were part of the early-20th-century civic awakening on Beacon Hill. Some believe that they were the instigators of that awakening.

After they married in 1904, the Bournes moved to a house as interesting as they would prove to be. Charles Luce had renovated the 1840 house at 130 Mount Vernon Street in 1878 into a colorful, quirky stucco-and-tile cottage, different from a typical brick row house. It became known as the Sunflower Castle. Their son Philip was born in 1907.

Gertrude was a founder and first president of the Beacon Hill Garden Club, organized in the fall of 1928. The founders created two traditions that continue to this day.

They entered an exhibit of a small urban garden in the New England Spring Flower Show. The club still participates in this spring competition. Club members also hosted the first Tour of the Hidden Gardens in 1929, charging $1 for 11 garden showings. They gave away the proceeds of $1,030 to horticulture and environmental groups. Since then, the club has donated more than $1,000,000 to such organizations, raising the funds though its tour, held every third Thursday in May.

While Gertrude was busy with the garden club, helping residents turn the open spaces behind their houses from laundry yards and privies into beautiful gardens, Frank was at work on his own venture. He was part of the group that in 1922 founded the Beacon Hill Association, now the Beacon Hill Civic Association; the organization is devoted to protecting Beacon Hill's quality of life.

Frank designed Charles River Square and others on the flat of the hill. He was instrumental in saving Asher Benjamin's Charles Street Meeting House at the corner of Mount Vernon and Charles Streets. He helped raise the money to move the building 10 feet west to accommodate the widening of Charles Street in 1920.

In 1932, the Bournes visited London where a friend took this photograph in front of 9 Chesterfield Gardens, the headquarters of the London Garden Club. (Beacon Hill Garden Club.)

Rose Nichols

Rose Standish Nichols was a garden designer, author, illustrator, suffragist, philanthropist, and traveler. When she died in 1960 at age 88, her will specified that her 1804 Bulfinch-designed home and its contents be preserved and open to public viewing. The Nichols House Museum was born.

The museum shows how an upper-class Boston family would have lived in the early 20th century. Dr. Arthur Nichols bought the house in 1885 for himself, his wife, and three daughters. The eldest, Rose, inherited the house in 1935.

Rose hosted a reading club in her parlor. From the left are Rose, Mrs. Williams, Mrs. Frank Nichols, Margaret Shurcliff, Frances Mintern Howard, and Mrs. Putnam.

Rose's house is a center of hill life, with neighbors and its small staff caring for the house and its treasures, becoming friends in the process. (Both, NHM.)

Marian Nichols

Marian Nichols (1874–1963) was the second of three daughters of Arthur and Elizabeth Nichols. She fought for women's suffrage. In 1920, she ran unsuccessfully for state representative but led a successful charge against the city's plan to repave Mount Vernon Street with red paving blocks. She was a founder and secretary of the Beacon Hill Association. (NHM.)

Margaret Nichols Shurcliff

Margaret Shurcliff, the youngest Nichols daughter, is credited with starting the Beacon Hill tradition of hand bell ringing on Christmas Eve. Margaret was the adventurous type. She was an award-winning tennis player, an enthusiastic carpenter, and a labor union advocate. She married Arthur Shurcliff, the landscape architect who designed Colonial Williamsburg, Sturbridge Village, and in the 1930s, the Charles River Esplanade. (NHM.)

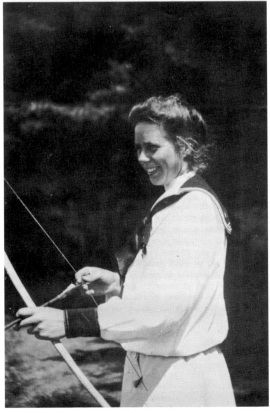

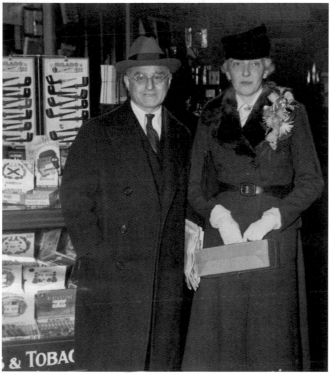

Frankfurter and Hill

Felix Frankfurter helped his neighbor Arthur Hill when Hill unsuccessfully represented Sacco and Vanzetti in their appeal in the mid-1920s. Frankfurter is shown above with his wife, Marion, at the Back Bay Station waiting for the train to Washington, where he would be sworn in as Supreme Court justice. Hill, at right, stands with his law partner Robert S. Barlow.

Sacco and Vanzetti had been convicted of murdering two men in Braintree, Massachusetts. Bigotry toward Italians and fear of foreign agitators tainted their trial. Sacco and Vanzetti were executed in 1927. Gov. Dukakis issued a proclamation admitting that the pair had had an unfair trial. He rejected pardoning them. That would imply they were guilty. (Above, BPL; right, Portsmouth Athenaeum.)

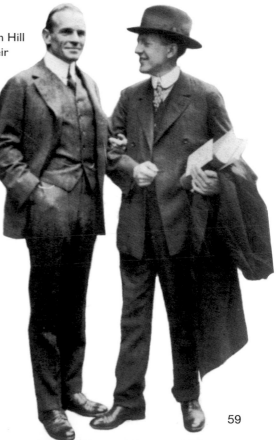

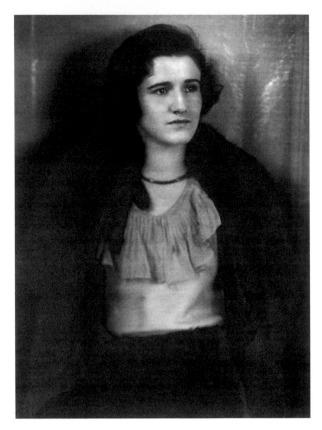

Margaret Welch

Margaret Pearmain Bowditch Welch was a woman of imagination, daring, and quiet determination who gave younger women the confidence to be as original as she was.

Margaret came to 20 Louisburg Square, where Jenny Lind had gotten married, when she married lawyer, businessman, and yachtsman Edward Sohier Welch in 1926. Both she and he had been divorced, and some neighbors were scandalized.

Although she was petite, only five feet, two inches tall, she was formidable. Ahead of her time politically, she was not afraid to speak up. As a young woman, she campaigned for women's suffrage. Later, she championed birth control, civil liberties, and conservation. She famously fought against roadside billboards—tricky since just down the block lived the Donnellys, whose company placed those billboards.

She was a Quaker and a member of the America First movement before World War II.

When Beacon Hill's brick sidewalks were threatened, she led the charge to save them. She commissioned a statue of Mary Dyer and got it placed in front of the State House. Boston's Puritans had hanged Dyer in 1660 for following the Quaker religion. Later, Margaret demonstrated against the war in Vietnam and crusaded for the bottle bill, which required merchants to accept returns of bottles so they would not become litter.

The Welches lived well. Margaret served tea promptly at five o'clock in the afternoon and invited good conversationalists. In 1934, the Welches introduced Waltz Evenings to Boston society by inviting 10 couples to their house to dance. The dances were moved to the Copley Plaza hotel and lasted until the end of the century. In 1935, the couple booked first-class passage on the newly christened ship, the *Normandie*, for a trip from New York to France. Neighbors say that Sohier (pronounced Sawyer) liked to take his wife to Paris to buy her clothes. Sohier died in 1948, but Margaret lived until 1984, dying at age 91. (Steve Judge.)

Sledding on the Boston Common

Some residents who grew up on Beacon Hill have found it hard to leave. Tom Townsend, a real estate broker who lives on Chestnut Street with his wife, Mary Fran, grew up on Beacon Hill. In 1938, his grandfather Howard gave him a sled, so his nurse Madeline Figuierado took him sledding on the Boston Common. (Thomas Townsend.)

Harold Hodgkinson

Harold Hodgkinson was manager of the legendary Filene's Basement in 1931. The basement was famous for selling well-made clothing at low prices.

On the day of the Brooks Brothers' sale, Hodgkinson would leave his Chestnut Street house and walk across the Boston Common to the store. Unlocking the doors, he would encounter all his Beacon Hill neighbors, ready for a good deal. Bostonians dearly miss Filene's Basement, which closed in 2011. (*Boston Herald.*)

Louis Brandeis

It was on again, off again for the relationship of Mayor James Michael Curley and Louis Brandeis (on the right). Brandeis, a son of immigrants born in 1856 in Kentucky, was a straight arrow whose intellectual family had been excoriated because they were abolitionists. Curley, on the other hand, was a tricky fellow who, at one time, sat for an examination under another man's name and was imprisoned for it. Curley was also one of the US congressmen who helped block Brandeis's appointment to Pres. Woodrow Wilson's cabinet. Their body language in this photograph does not show much camaraderie.

But they had a common enemy in certain Boston Brahmins. That aristocracy did not much like Curley, and many of them, including the president of Harvard and Sen. Henry Cabot Lodge, opposed Brandeis's nomination to the Supreme Court. After all, although Brandeis had been Harvard Law School's most successful student ever, he was a Jew.

But on Beacon Hill, land of the Brahmins, Brandeis and his family lived a comfortable life at 6 Otis Place. Brandeis managed a successful law practice in Boston with his classmate, Samuel Warren, the scion of an old Brahmin family whose family had grown wealthy through ownership of paper mills. Sam proved that not all the aristocrats were bigoted. Their law firm still exists as Nutter, McClennen & Fish, LLP.

Brandeis left Boston in 1916 to become a Supreme Court justice. Throughout his life he warned against monopolies and certain banking practices. He championed free speech, defended the right to privacy, and mentored his friend Felix Frankfurter when he was appointed to the court. (BPL.)

Frances Howard

Frances Minturn Howard, poet, lived with her husband, Thomas Clark Howard, on Mount Vernon Street. Born Frances Hall in New York in 1905, she took Minturn as a literary name. She wrote the garden club's first book, *The Hidden Gardens of Beacon Hill,* in 1959. She helped carry on Beacon Hill's literary tradition. *All Keys are Glass* appeared in the late 1930s; *Sleep Without Armor* was published in 1953. (Frances Howard.)

John Berryman

John Berryman is a good example of the poets who were attracted to Beacon Hill in the middle of the 20th century. They critiqued one another's work and gathered at one another's apartments for food, drink, and conversation. In the 1940s, Berryman lived on Grove Street with his wife, Eileen. He was carrying on with another woman, and his marriage did not last. Robert Lowell, another notable poet, grew up on Beacon Hill and wrote about his youth in the essay, *91 Revere Street.*

Both men struggled with depression. Berryman moved to Minneapolis. He committed suicide in 1972 by jumping off a bridge into the Mississippi River. Lowell died of a heart attack in 1977. (BPL.)

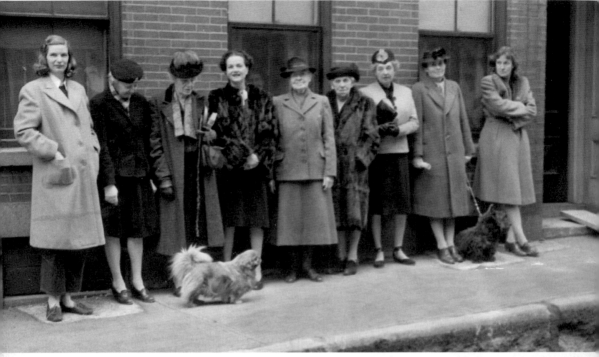

Battle of the Bricks

In April 1947, city workers without warning began digging up Beacon Hill's brick sidewalks to replace them with concrete. This went over poorly with the residents.

These ladies sat on their bricks until Mayor Curley relented. From time to time, sidewalks again come under attack. They are uneven, slippery, and too narrow, but they are history. People walk in the street anyway. (*Boston Herald Traveler* archives.)

Sister Winifred

Sister Winifred represents the Sisters of St. Margaret, an order of Episcopal nuns who moved to Louisburg Square in 1883 because a sister owned a house there. Experienced nurses, they worked at Children's Hospital and served the poor at the Church of the Advent. They were a happy part of hill life until 1988, when they moved away. Their corner house is now a home of John Kerry and Teresa Heinz. (Sisters of St. Margaret.)

Rowing from the Union Boat Club

These crew members claim they were never defeated. Joe Eldredge (at left) was the stroke. Then came Fred Newcomb (second from left) and John T. Potter (third from left). In the bow was Tom Plummer (at right). These recent college graduates were members of the Union Boat Club, a rowing and squash club, in the 1950s and beyond. Joe and his wife, Jody, went on to become an important part of the community in all its doings.

The Union Boat Club was founded in 1851, about a century before these young men climbed into its shells. Such Beacon Hill residents as Adm. Richard E. Byrd, future Supreme Court justice Louis Brandeis, and landscape architect Arthur Shurcliff were members. Naturally, the club built its clubhouse right on the Charles River at the end of Chestnut Street. The 1910 building still stands.

Then came land filling, park expansion, and construction of Storrow Drive, a major thoroughfare. The clubhouse was no longer on the river, but several hundred feet away. So the older building now is used for handball, squash, and meetings, while a boathouse has been built on the river. Charles River Esplanade users often encounter the rowers moving their shells in and out, especially on early summer mornings. (Joseph L. Eldredge, FAIA.)

Richard E. Byrd

Rear Admiral Byrd (1888–1957) lived in his wife's girlhood home on Brimmer Street when he was not exploring the north and south poles. He and Marie raised their four children in the house and took them for rides on the Swan Boats in the Public Garden. But Byrd was also known for his dogs, some with polar-inspired names. Here, he is on Brimmer Street with Iceberg in 1935.

According to an article in the *Boston Globe* in 1928, Byrd's regimen was the same every day when he was at home. He came down for breakfast with his family around eight in the morning, drank a bit of tea, and went into his office. There, with a secretary, he tackled the mail, which was full of offers to accompany him on one of his journeys to the South Pole. He took a walk at noon, usually with his son, Dick Jr., and a dog or two. About five, he went out to play squash, tennis, or golf. He would have a glass of milk about 11 p.m. and go to bed. It sounds as if his had a quiet home life, especially compared to his well-known adventures. His wife was once called the "first lady of Beacon Hill." (*Boston Herald Traveler* archives, BPL.)

Samuel Eliot Morison

It is hard to understand how the naval historian Samuel Eliot Morison (1887–1976) had time for anything else, given his prodigious output. He and his second wife, the singer Priscilla Barton, are seen here going to the opera on April 22, 1952.

Morison grew up at 44 Brimmer Street, a house his maternal grandparents had built in 1872. In *One Boy's Boston,* he describes vividly the noise and animal smells that infected Charles Street, with the trolley that ran down the middle.

He is remembered for his *Maritime History of Massachusetts,* in which he hails the settlers' ingenuity in turning the colony's liabilities into advantages. "The long-lying snow gave cheap transport inland, the river rapids turned grist and fulling mills, then textile factories; even granite and ice became currency in the Southern and Oriental trade." He wrote *The Life of Harrison Gray Otis* since, as an Otis descendant, he had the man's papers in his basement.

He is probably best remembered among historians for his 15-volume naval history of World War II because he had persuaded President Roosevelt to take him on at age 55 as a lieutenant commander in the Navy. He rose to the rank of rear admiral.

Except for travel, summers in Maine, a couple of teaching stints, and his time away in both world wars, Morison lived his entire life on Brimmer Street. Priscilla lived there until she died at age 66 in 1973.

While Morison followed in the footsteps of such hill residents and historians as William Hickling Prescott, he said if he were able to live life over again, he "would have been an explorer like Adm. Richard Byrd in Antarctica." (BPL.)

Christian Herter

State House leaders have always made their homes on Beacon Hill. Convenience is probably the reason.

Gov. Christian Herter (1895–1966) lived on Beacon Street. He was a diplomat, a state representative, a congressman, Massachusetts's governor, and later, secretary of state. This photograph shows his predecessor, Gov. Paul Dever, right, handing over the gavel to Herter on January 8, 1953. George Hoyt took this photograph. (*Boston Herald Traveler* archives, BPL.)

John P. Marquand

John P. Marquand (1893–1960), author of the deliciously satirical novel *The Late George Apley*, is said to have based characters on his neighbors, Margaret and E. Sohier Welch, who loved the gesture. In this photograph, Marquand (at left) greets the actor Grant Mitchell on the way to Hyannis. Mitchell was appearing in the play at the Cape Playhouse. (BPL.)

Robert Frost

Robert Frost carried on the tradition of authors living on Beacon Hill when he moved to 88 Mount Vernon in 1938. He also carried on the tradition of moving back and forth between Cambridge and Beacon Hill. Frost was a mentor, a critic, a friend, and an annoyance to these 1950s poets. But they all revered him. (HNE.)

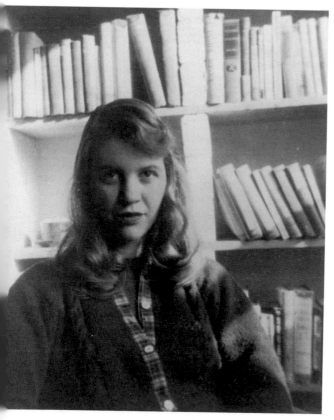

Sylvia Plath

Sylvia Plath and Ted Hughes lived in the 1950s on Willow Street. She worked at Massachusetts General Hospital transcribing mental patients' records when she was not writing poetry. The couple socialized with the other poets living on the hill. W.S. Merwin was at 76 West Cedar Street. George Starbuck and his family were on Pinckney Street. (BPL.)

John Codman

Real estate man John Codman (1899–1989) is remembered on Beacon Hill for his "doggedness" in more ways than one. John had Zodiac, a wirehaired terrier that came up to his knee. John would emerge from his "Hidden House," which he reached through a tunnel under 74 Pinckney Street, to walk his dog.

Zodiac had a particular talent. John would stand on the sidewalk, chatting with a neighbor, and Zodiac would spring straight into the air with all four legs out, much like the British Harrier Jump Jet takes off.

Codman's doggedness was shown in another way—historic preservation. In 1955, he led neighbors in persuading the Massachusetts legislature to create the Beacon Hill Architectural District, which made any visible changes to a building's exterior subject to the approval of the Beacon Hill Architectural Commission. Codman served as the commission's first chair.

That legislation covered only the south slope of Beacon Hill. Amendments in 1958 and 1963 extended the protection to the entire neighborhood bounded by Storrow Drive, Beacon Street, Bowdoin Street, and 40 feet in from Cambridge Street, as well as a short distance down Park and Beacon Streets. In 1962, Beacon Hill was also protected by a National Historic Landmark designation.

Beacon Hill was not the first historic district. That occurred in Charleston, South Carolina, in 1931. But protecting Beacon Hill's architecture became a model for other Boston neighborhoods. Now, the Back Bay, Bay Village, St. Botolph, the South End, and parts of Charlestown, Mission Hill, the Fort Point Channel, Brighton, and Kenmore Square are also protected.

Such designations are good news for property owners. Property values within historic districts appreciate significantly faster than the market as a whole, studies have shown. They also bring comfort—your neighbor is generally prevented from doing something stupid to his house.

Codman also helped found Historic Boston, Inc., which buys historic properties, rehabilitates them, and finds new uses for them that enhance their neighborhoods and contribute to the city's economic vitality. Historic Boston's first project was to raise the money needed to acquire and preserve the Old Corner Bookstore, the 40-year home of Ticknor and Fields, publishers of Hawthorne, Thoreau, and Dickens. (Codman family.)

CHAPTER FIVE

Resurgence

In the 1950s, 1960s, and 1970s, despite the allure of the suburbs, Beacon Hill saw the beginnings of a back-to-the-city movement. Young families like the one headed by Susan McWhinney-Morse bought the historic buildings that had been turned into rooming houses. They renovated or restored them and settled in. Young, vigorous couples like Gael and Connaught Mahony moved in, found their older neighbors eccentric and fascinating, and set about making the neighborhood more welcoming for children. They took advantage of a new children's library started in the living room of an Acorn Street house and sent their children to the newly founded nursery school. Toni Norton, John Bok, Joe Eldredge, and others founded Hill House, a community center that gave the Beacon Hill Nursery School a home in its basement and the Beacon Hill Civic Association a permanent office on the main floor. Neighbors started a window box contest that has made flowers in the windows an iconic image of Beacon Hill.

Charles Street still had its antique stores. Best of all, it had a thriving hardware store and pharmacy that had acquired new owners, Dick Gurnon and Herman Greenfield, whose congeniality and trustworthiness soon made them beloved. Their shops became even more popular gathering spots where neighbors met neighbors and joked with the people behind the counters.

Boston was still languishing economically as factories closed and large companies moved to places they thought would offer more advantages. But soon, a new kind of economy featuring finance, science, technology, medicine, and education, all the commercial sectors Boston already had, would become more important than traditional manufacturing.

Beacon Hill was ready when Boston's economy surged and people started to move back into cities in the 1980s. The neighborhood had mature institutions, the protections that came with the historic district designation, a subway station within a short distance of each of its four corners, and retail spaces too small for the franchises that can make every American business district look alike.

Of course, it was hard to find a parking place. The city had created a program whereby only residents whose cars were registered on the hill could park legally on the street. But there were four times as many cars with resident stickers as there were spaces. Somehow drivers worked it out, and difficult parking was accepted as a good trade for the convenience of not having to drive at all.

Above all in the neighborhood's chances for success was its residents' active and devoted civic engagement, which fostered sociability, creativity, and important lessons in how to keep a neighborhood strong.

Window Box Project

Mary Jean Yeates and Carol Rossi are preparing window boxes on May 4, 1958, while Officer Patrick Canning of Division 3 appears to be supervising. This was the year that members of the Beacon Hill Garden Club and the Beacon Hill Civic Association decided flowers should beautify the neighborhood. They started a contest to encourage residents to install window boxes, fill them with flowers, and maintain them all summer. Beacon Hill residents have been doing this ever since.

Everyone got into the act. The parks department provided 18 tons of loam. The local Boy Scouts, Boston Latin School students, and the delivery boys from a local supermarket volunteered to build and paint the wooden boxes. Metal or plastic boxes would "either drown or cook" the plants, said Rosemary Whiting, one of the organizers. The hill's elementary school students helped too, with the boys building the boxes and the girls planting them. (It was a different time.)

George Taloumis, editor of *Horticulture* magazine and a *Boston Globe* garden columnist, was tapped to give a talk explaining how to maintain a window box. Such men as Carmen DiStefano and Gael Mahony, who at the time was president of the civic association, got involved. Women such as Mrs. Houlder Hudgins, Margaret Welch, and Peter Eacker helped out.

The contest now awards prizes three times a year and incorporates photography. Boxes hold hydrangeas, geraniums, and petunias in the summer; gourds, peppers, and leaves in the fall; boxwood and other greens in the winter; and daffodils and pansies in the early spring. No fake plants allowed. (*Boston Herald* archives, BHCA.)

The Circle for Charity

In the 1960s, neighborhood women founded the Beacon Hill Circle of the Florence Crittenton League, which helped unwed mothers. They raised money through fairs, like this one in Louisburg Square. Later, they expanded their mission to support all needy women and children in Boston. As the Circle for Charity, they have donated over $750,000, raising funds now by offering groups a tour of three private homes. (Circle for Charity archives.)

Father Day

The Advent School opened in 1961, founded by members of the Church of the Advent who wanted a school that reflected the diversity of Boston, championed learning, and fostered collaboration and respect.

In 1965, the Rev. Robert C. Day became head of school for 30 years, followed by Nancy Harris Frohlich, and in 2012, Nicole A. DuFauchard. The school is no longer associated with the church. (Advent School.)

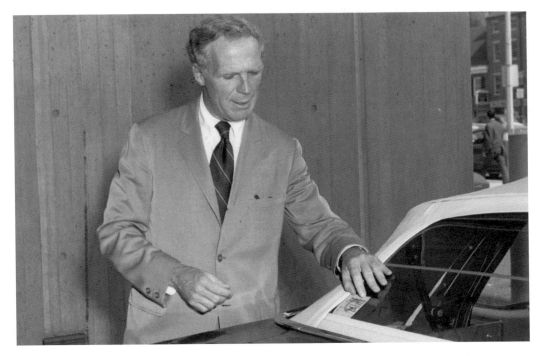

Mayor White

One might wonder why Kevin White (1921–1912) looks so interested in a sticker on the back window of a car.

It was during his 16 years as mayor that Boston's resident parking program was instituted. The first neighborhood to try it was Beacon Hill. The program restricted street parking to residents whose cars were registered in the neighborhood. But hill residents still had few places to park since four times as many stickers existed as there were spaces.

It was a heady time when White became mayor in 1968, bringing with him young, energetic hotshots, including another Beacon Hill resident, Katharine Kane, and the irrepressible Barney Frank, who went on to become a US congressman.

White's staff reflected the new Boston—diverse, well-educated, results-oriented, and progressive. He had defeated school committee member Louise Day Hicks, an opponent of school desegregation. His administration rejected the tribalism and cronyism of the old Boston, not that those attributes went away entirely.

He presided over a building boom that gave Boston new life, a 350th anniversary of the city's founding, and the stirrings of a new urbanism. But he also had to oversee polarizing school busing.

One of his goals was to bring a better quality of life to every neighborhood in Boston, and Beacon Hill benefitted. Mayor White lived on lower Mount Vernon Street, and he and his wife, Kathryn, raised their five children there. He is remembered for his cheerful walks around the neighborhood, often with children in tow, and his affection for the Paramount restaurant.

He helped Beacon Hill residents achieve long-sought goals. He reinstalled brick sidewalks and gas lamps, many of which had been discarded. Then he reversed the traffic on the neighborhood's main street.

For years, residents had complained that noisy, traffic-clogged Charles Street served suburban drivers anxious to get home better than it served the neighborhood. So, on Sunday night, November 7, 1982, Mayor White, with no warning, had the police change the traffic signs.

Drivers no longer had easy access from Beacon Hill to major roads out of the city, and those coming in found Charles Street offered no advantage. The street's new calm welcomed pedestrians and boosted business. Neighborhood leaders then worked with the city to erect a traffic island at Beacon and Charles Streets that would make the traffic direction permanent. (BPL.)

Herb Gleason

Mayor Kevin White plucked from Beacon Hill many neighbors for his administration. Herb Gleason was one. He served as Boston's corporation counsel from 1968 to 1979. He and his, wife, Nancy lived on Pinckney Street and, later, moved to private Byron Street so they would have a place to park. They were both active in the Arlington Street Church and Democratic politics throughout their lives. (BHN.)

Ed and Liz Driscoll

Edgar "Ed" J. Driscoll Jr. and Elizabeth "Liz" Watts met at the *Boston Globe* in the early 1950s. Ed eventually gained fame as the *Globe*'s obituary writer and got much satisfaction as an artist. Liz wrote for the *Beacon Hill News* but also became a teacher and a community activist. They were part of a lively crowd who enjoyed parties, wit and wisdom, and city life. (Edgar J. Driscoll III.)

Gary Drug

Jack Raverby was the proprietor of Gary Drug from 1936 to 1972. His pretty, pleasant wife, Sophie, joined him in the shop when their daughter was a teenager. Jack was an accommodating yet serious sort who could often be found behind the counter reading the *New Republic,* ready to talk politics with such customers as Henry Kissinger, Kevin White, and Ted Kennedy.

Jack was nine when his family came to Beacon Hill in 1919 from the Ukraine. He had graduated from the Meriano School of Pharmacy and worked at a Cambridge Street drugstore where the pharmacist was also bootlegger.

Jack's first partner, Harry Dolan, named the business after his son. After Dolan died, Jack Mirkin became a partner. A busy soda fountain was eventually removed because the store was too narrow for customers to get by.

Herman Greenfield bought Gary Drug in 1972 when the hippies were leaving and young families were moving in. Herman had gone to Boston University in political science, worked in Washington, and then went to the New England School of Pharmacy on Mount Vernon Street. Herman and Jack Raverby enjoyed a warm friendship, and for some years, Herman employed Jack as a part-time druggist. (BHN.)

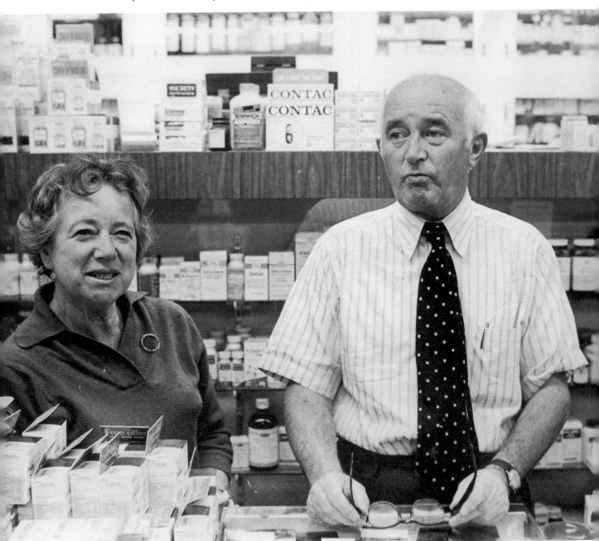

Sam Bass Warner Jr.

Beacon Hill always attracted historians, perhaps because it is so easy to get to Harvard, Boston University, and MIT. Sam Bass Warner was the preeminent historian in the mid-1900s focusing on how cities operate. It is hard to go to Brookline outside of Boston or Winnetka north of Chicago without thinking of *Streetcar Suburbs*, Warner's 1964 book, and how the streetcar fostered their growth. (Sam Bass Warner Jr.)

The Boston Strangler

This neighborhood is safe. But between 1962 and 1964, "the Boston Strangler" was raping and strangling women who had let him into their apartments. Two victims, Ida Irga, 75, of Grove Street, and Mary Sullivan, 19, who lived above the Paramount, a popular restaurant on Charles Street, were from Beacon Hill. Doubts lingered about Albert DeSalvo's guilt, but DNA finally confirmed he was the murderer. (*Boston Herald* archives, BPL.)

Peter Davison and Joan Goody

Poet Peter Davison and architect Joan Goody lived on River Street. Peter, an *Atlantic Monthly* editor, revealed his affair with Sylvia Plath, along with other Beacon Hill poets' intimate affairs in *The Fading Smile*. He died in 2004. Joan's first husband was Marvin Goody, a founder of the architecture firm Goody Clancy. Joan was active in her profession until she died in 2009. (Goody Clancy.)

Marika Raisz

Marie (Marika) Georgette Raisz set up her shop on Beacon Hill in the early 1960s. She was born in Hungary in 1900 and came to America in the 1920s with her husband, the cartographer Erwin Raisz. Marika's, now run by her grandson Matthew, is the oldest antiques shop left on a street that, at the time of Marika's arrival, boasted at least 30 such shops. (Matt Raisz.)

Smoki and Dick

Smoki Bacon and Dick Concannon have known every important Bostonian and have participated in every major Boston event for the last 40 years.

They have experienced tragedy, recovery, romance, involvement, and fun. They have witnessed Boston's change from dull convention to energetic diversity. They were prime movers behind this change.

Adelaide Ginepra, born in 1928, grew up modestly in Brookline, Massachusetts. In high school, boys teased her, calling her Smoki, so she adopted the name. She trained in art, worked as an illustrator, and moved to Beacon Hill.

She met Edwin Conant Bacon, son of a Brahmin family. He asked her for lunch. But she had a dilemma. She already had a date with another man. She decided to go with the first to arrive at her door. She and Ed were married a few months later. Newspapers labeled her a socialite.

In 1974, Ed died at his desk at his insurance agency. Police said he had had a heart attack. Then, Smoki was told Ed had committed suicide, taking cyanide in his coffee. But he had been murdered. Ed's associate James Blaikie had forged Ed's signature and changed the beneficiary of Ed's insurance policy to himself days before Ed's death.

Blaikie died in prison, convicted of murdering another man. Smoki sued the insurance company for negligence in accepting the forged signature.

She lost the insurance battle but persuaded the legislature to pass the Ed Bacon law, forcing insurance companies to notify customers of new beneficiaries and to verify signatures.

Richard Concannon was Ed's classmate. Dick had worked in the steel business in Texas, Alaska, and Central America. Later, he went into retail and real estate. He got married and then divorced.

Meanwhile, Smoki began arranging events for the Friends of the Public Garden, the 1976 Bicentennial and Boston's 350th anniversary.

They met at a Harvard reunion and married in Harvard Yard in 1979 with 800 people in attendance.

In the 1980s, they hosted a radio and television show in which they interviewed influential people. Now, they conduct *The Literati Scene*, a television show on Boston Neighborhood Network. They have hosted everyone from Bill Clinton to Bill O'Reilly.

There are two things Smoki wants readers to remember—she got the name Smoki before she married Ed Bacon, and she is not a socialite. (Smoki Bacon and Dick Concannon.)

Nonnie Burnes

Nonnie and Ricky Burnes were among a large group of families who decided in the 1960s and 1970s to raise children in the city, not the suburbs. The whole family liked to ski. They had a great opportunity to indulge their love of the sport in 1978. Boston endured—although many will say the city enjoyed—more than two feet of snow in about a day. Nonnie took her kids Ethan, Sarah, and Gordon out for a ski on the frozen Charles River where Ricky snapped this photograph. (Burnes family.)

Thalassa Cruso

British-born Thalassa Cruso lived on Beacon Street on Beacon Hill for many years, tending her seaside garden in Marion, Massachusetts, in the summertime. She shared her eccentric, authoritative gardening ploys with viewers on her popular 1960s public television show, *Making Things Grow*. Her wit and take-no-prisoners style of gardening came through in the television show, in her books, and in frequent appearances on *The Tonight Show Starring Johnny Carson*. (Ala Reid.)

Susan McWhinney-Morse and David Morse

Susan McWhinney-Morse's life mirrors Beacon Hill's struggles and successes during the last half of the 20th century and the first years of the 21st.

Like 60 percent of Beacon Hill's residents, Susan is not a Massachusetts native. She was born in Denver in 1933, came East for school, and stayed. In the early 1960s, she and her first husband bought a spacious row house filled with elegant detail. It was a "dirty, dusty, terrible place," she said, on tree-less Temple Street, named for Lady Elizabeth Bowdoin Temple, wife of the British consul, Sir John Temple, who served immediately after the Revolution.

Things have improved.

First, though, she and her neighbors had to stop Suffolk University, growing and greedy for space, from destroying historic buildings. It helped that Susan was persistent and persuasive. They eventually pushed that institution to the edge of the neighborhood. Actually, though, those successes took an act of the legislature and three lawsuits.

Then they worked to improve their cherished neighborhood.

They persuaded the city to narrow Temple Street, widen its sidewalks, and plant trees. They fixed up historic houses that had been neglected throughout the Depression, World War II, and the 1950s move to the suburbs.

Susan raised four children, and like many Beacon Hill families, took in boarders. She has always been active in neighborhood groups. She ran the Hidden Gardens Tour for the Beacon Hill Garden Club. She became the first woman president of the Beacon Hill Civic Association. She has been a longtime member of the Beacon Hill Reading Group.

She married lawyer David Morse in 1995, and her house is now a handsome triplex with apartments above.

Because her house is now comfortable and because products, services, and sociability are so easy to find on Beacon Hill, she and other residents determined they could never move to a retirement community when they grew old. So in 2002, they formed Beacon Hill Village, an organization that helps members stay in their homes, in the neighborhood they love, surrounded by people of all ages and circumstances, as they grow old. Susan served as one of its first presidents. (BHCA.)

Dan Macmillan

Dan Macmillan was the editor of the *Beacon Hill News*, the longest-running newspaper so far on Beacon Hill.

In 1946, Raymond Bearse, a sometime journalist with the Associated Press, began publishing an earlier *Beacon Hill News*, but it lasted for only two years.

In the mid-1960s, the Beacon Hill Civic Association asked Dan to start a newspaper for that organization. He was happy to do it. As a member of the family that had founded the Macmillan publishing empire, he knew something about print. And he was looking for something in the community to do since he had left his incipient baseball career when the Red Sox assigned him to a Class D league team in the Carolinas.

After a few years, Dan and the civic association amicably parted ways, and he ran the paper as an independent monthly, covering the news of Beacon Hill and, later, expanding to sister publications in the Back Bay and the West End.

Poet Frances Minturn Howard wrote for the *Beacon Hill News* as did former Globe reporter Liz Driscoll and poet Jean Kefferstan. Gail Weesner was a regular writer too. The piece she is best remembered for was a thorough description of that urban scourge, the Norway rat.

During these years, the *Ledger* and *Tab* were also published, but they were never directed solely at Beacon Hill.

After Dan died in 1995, Beacon Hill enjoyed for a time two newspapers, the *Beacon Hill Times*, a weekly Karen Cord Taylor founded, and the *Beacon Hill Paper*, later to become the *Beacon Hill-Back Bay Chronicle*, founded by Bettina "Toni" Norton. The *Beacon Hill Times* survives, now owned by weekly newspaper mogul Stephen Quigley, a Chestnut Street resident. (BHN.)

Dick Gurnon

This photograph shows the Gurnons and their staff in the 1990s. At top, from left, are Michael Haley, Norm Solari, and a bearded Jack Gurnon. Jerry Christoffels is the man holding Emilie Gurnon's shoulders. Next to her are Dick Gurnon and daughter Meg. Dick holds Jack's wife, Cassie. They look happy, but that was not always the case.

One spring night in 1963, Dick, age 37, was asleep at his home in Danvers, north of Boston, when the phone rang.

"Your hardware store is on fire," the caller said.

Dick was there in 15 minutes. Someone had set fire to trash in the alley behind the store, and the flames had spread. Firefighters had put out the fire by the time he got there. The building had survived, but little of the inside was left.

Dick was dumbfounded. He had insurance but not enough. He had owned the store for 11 years, and it supported him, his wife Emilie and their children, Richard, Meg, and Jack.

The neighborhood depended on Dick to supply everything from paint to shower curtains to Swiss Army knives.

Neighbors also depended on Dick to monitor the street. When a car's engine caught fire on Charles Street, it was Dick who put out the blaze. When the police were looking for a suspect who was breaking into apartments, it was Dick who spotted him on the sidewalk. He kept neighbors' keys and helped them break into their own houses if they lost them.

Residents came to commiserate. Someone told Dick that a Louisburg Square resident wanted to see him, so Dick walked up.

The man ushered Dick in, set him down, and asked how much it would cost to get him back in business. Dick named a figure. And the man, who asked to remain anonymous, wrote him a check.

No lawyer, no contract, no questions.

"Pay me back when you can," he said.

By September, Dick was back in business and his family has been so ever since.

Dick's son Jack now owns the store, living up above with his wife and twin daughters. Jack is now the one who breaks into houses and puts out blazes in car engines.

He and his staff monitor the street the same way Dick did. The store carries everything a person could need, rents tools, cuts glass, and repairs lamps. It is different, but it is the same. (Gurnon family.)

Joan and John Bok

John and Joan Bok were the first married couple to pass the bar examination together in Massachusetts. They used their legal training to work with their neighbors to make Beacon Hill a better place for young couples to raise families.

When the couple moved to the neighborhood in the mid-1950s, Beacon Hill had many rooming houses. To encourage young families to choose Beacon Hill rather than the suburbs, the hill needed more single-family houses. So John and Joan got together in the 1960s with some Pinckney Street neighbors, including an architect and other professionals, and bought three rooming houses, converted them into single-family houses, and sold them to young families.

In addition, due to Beacon Hill's central location and relatively low rents compared to prime downtown locations, lawyers and other professionals attempted to open offices in what had been housing. The Boks and their neighbors feared offices would make portions of the hill seem like business districts and would reduce the residential area. They used their legal skills on zoning to help block the conversions of houses into offices.

John was active in other neighborhood matters. He served as president of both the Beacon Hill Nursery School and the Beacon Hill Civil Association and worked to convert surplus public school buildings on the hill into housing. Joan was active in the effort to get owners to replace coal furnaces with gas ones, as the coal furnaces were fouling the air and were illegal.

Both John and Joan initially practiced law at Ropes & Gray. John went on to head his own law firm, while Joan became chairman of what was then known as the New England Electrical System. Most importantly to them, they raised their two boys on the hill. (John and Joan Bok.)

Connaught and Gael Mahony

When Connaught O'Connell met Mike Mahony at a Harvard-Yale football game, she was smitten, as was he. He took her home to meet his mother in the Back Bay.

Connaught was puzzled. Mrs. Mahony kept talking about a man named Gael. It turned out that Gael had not liked his name, thinking it was too feminine. In college, he had changed it to Mike. Connaught loved his real name and insisted he use it.

They decided to give their children memorable names also. They came up with Medb (Maeve), Ieuan Gael (Ian Gael), and Eoghan Ruadh (Owen Roe); the children married a Sam, a Carol, and an Elizabeth, respectively.

The Mahonys moved to Pinckney Street after they married, Connaught was delighted to find that her neighbors lived up to their reputation as eccentric. "Everyone is so odd I don't stand out at all," said Connaught.

Miss Watson lived around the corner from the Mahonys, and she still had gaslights inside, said Connaught. When the civic association leaders painted instructions on the pavement to "please curb your dog," they found that Miss Watson was painting over their instructions with brown paint. Mrs. Crawford entertained the street for much of the day, playing the harp. She shoveled her own walk and played tennis until she was 81 years old. Margaret Welch wanted everyone to speak Esperanto.

Meanwhile, Gael was carving out a career as a well-known and respected trial lawyer. He was also a president of the civic association and instrumental in securing the historic district designation. Connaught was starting ventures of her own. When they counted 400 children living on the hill, she and other mothers founded the Beacon Hill Nursery School. She joined with other women eager for intellectual conversation to found the Beacon Hill Reading Group. Both organizations are thriving today. (Connaught and Gael Mahony.)

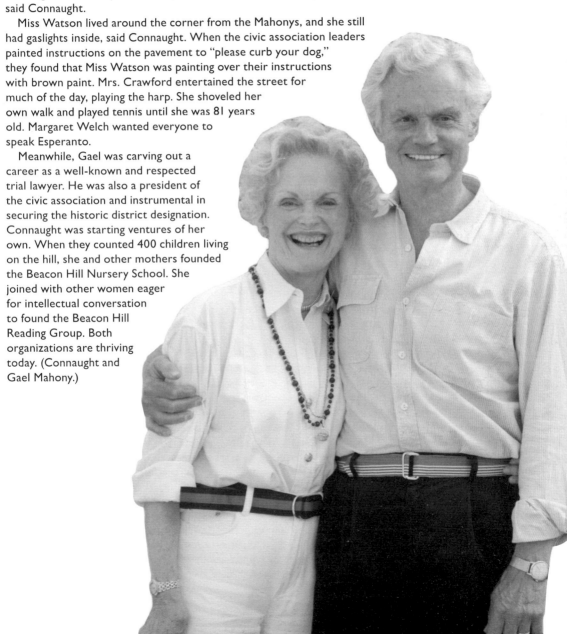

Henry Lee

Henry Lee can often be seen giving out awards or receiving them. In this 1990s photograph, Henry, second from left, accepts an award on behalf of the Friends of the Public Garden from Brian Gilbert, the city arborist. Brian was head of the Massachusetts Arborists Association, which recognized the Friends of the Public Garden for their work in caring for the great trees on the Boston Common. Also representing the Friends of the Public Garden are Eugenie Beal, left, and Stella Trafford, second from right.

The other man is Larry Dwyer, parks commissioner. On the far right is Victoria Williams, assistant parks commissioner.

The city's parks department and the Friends of the Public Garden have been working closely since 1970, when the Friends were founded, taking care of the Public Garden, the Boston Common, and the Commonwealth Avenue Mall in the Back Bay.

At first residents of Beacon Hill and their neighbors in the Back Bay and Bay Village were concerned about the deteriorating condition of the downtown parks.

But almost immediately it became clear that a proposed high-rise development, which would shade park plants for much of the day, was a greater threat. Henry Lee, who had agreed to serve on a volunteer basis as president of the group, brought his patrician voice, his good sense of humor, and his steadfast manner to bitter negotiations that were ultimately successful in stopping the project. But that happened only after Mayor Kevin White dropped his membership in the Friends.

The fight brought notoriety and publicity to the Friends of the Public Garden, who quickly grew in numbers and influence. Shadows are now restricted by state legislation in the Boston Common and Public Garden, and the Friends are consulted before anything happens around them.

Henry and his friends continued to run the Friends of the Public Garden for many years, but now, a permanent staff led by landscape architect Liz Vizza and a board led by Pres. Anne Brooke pay attention to 1,700 trees, 40 pieces of sculpture and memorials, and the Brewer Fountain Plaza and help the parks department with other projects in the parks. Henry continues as president emeritus. (BHN.)

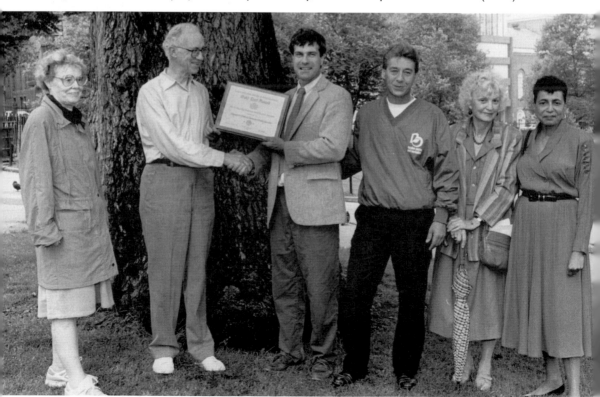

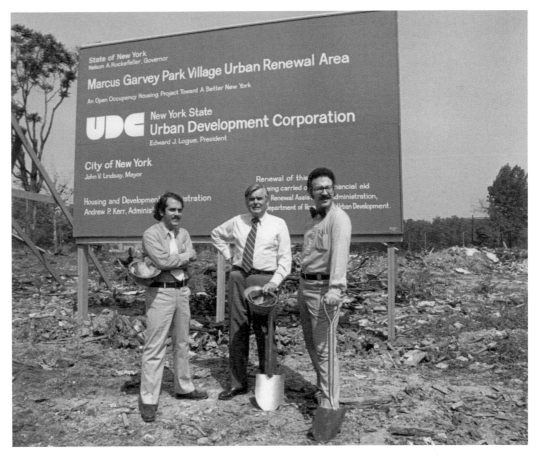

Anthony Pangaro and Edward Logue

In the 1960s, when newspapers predicted the death of cities, Beacon Hill residents Ed Logue and Tony Pangaro worked to save them. Their success is partly why Beacon Hill thrives today.

In this 1973 picture, Tony, at left; Ed, middle; and Ted Liebman were building affordable housing in New York. Earlier, in 1963, Ed had come to Boston to head the Boston Redevelopment Authority. He revamped it. No longer would the Boston Redevelopment Authority (BRA) be tearing down whole neighborhoods, as it had done in the West End in the 1950s.

Ed got award-winning architect I.M. Pei to do the master planning for Government Center and then got the federal government to fund much of it. He also ran the competition for the design of the new city hall. These projects had mixed success with the public, and Logue might not have fashioned them today as he did then.

But Faneuil Hall Marketplace has had no controversy. The developer James Rouse and architect Ben Thompson were well respected, but they could not get financing from banks skittish about investing in cities. Ed persuaded 10 banks to lend a total of $10 million to get the old produce and meat shops at Quincy Market transformed by 1976 into an emporium of restaurants and interesting stores. Bostonians loved the new market, and still call it Quincy. Tourists flock to the place. It became a model for festival markets throughout the country.

Tony went to work at the BRA shortly after Ed left, but then worked with him on other projects. Ed came back to Boston to live after his stint in New York. He died in 2000.

Tony now is a real estate developer with Millennium Partners. Much like Ed renewed Government Center, Tony is renewing Downtown Crossing, the old department store shopping district. His fifth project in the area is the complex on the site of the old Filene's Department Store. (Anthony Pangaro.)

Katharine and Louis Kane

In this photograph, Louis and Katharine Kane are slicing into their wedding cake with the same vigor in which they lived their lives. They lived on Beacon Hill from 1958 until he died in the year 2000 and she in 2013. They changed Boston, each in his and her own way.

Kathy was from Indianapolis, and Louis was from Boston's old West End. They met in Washington, DC, in 1956 while she was working for the CIA and he was a Marine Corps captain at the Pentagon. They moved to Beacon Hill, had three children, and got on with their work.

Kathy was involved in politics, first in the League of Women Voters, next as a state representative, and then as Mayor Kevin White's deputy mayor. She was in charge of fun. Her efforts did more to bring the city to life during the 1970s and 1980s than any other factor.

She created Summerthing, celebrating the arts and enlivening every part of Boston. She directed Boston 200, commemorating America's 200th birthday. She tapped local institutions, almost all of which mounted exhibits, lectures, performances, readings and movies, the most wonderful of which was *Where's Boston?*, created by the Cambridge Seven architecture firm. She helped get Boston's First Night off the ground and persuaded the Tall Ships to stop by for a visit for Jubilee 350, which celebrated Boston's founding.

Meanwhile, Louis was founding Au Bon Pain and Panera Bread, developing real estate, and managing other financial ventures. He was also cooking and skiing, his two recreational passions, and satisfying his civic passions by serving on boards of the West End Boys and Girls Club, the Institute of Contemporary Art, and Harvard.

At age 60, Kathy enrolled at Harvard Divinity School, earning a master's of divinity and a master's of theological studies. She became a chaplain at Brigham and Women's Hospital and conducted courses on religion at Beacon Hill Seminars. She served on numerous boards, such as MassKids, the Landmarks Orchestra, and the Boston-Strasbourg Sister City Association. She was on the vestry at the Church of St. John the Evangelist. She worked in those capacities almost until the day she died. (Kane family.)

The Hinkles

Joe and Sally Hinkle loved to get dressed up and go to parties. Here, it looks as if Joe is about to give a speech, which he often did. The couple was involved in many neighborhood organizations, and Sally had grown up here. Joe was the first treasurer of the Beacon Hill Nursery School, even though he had no children yet. Joe died in 1997. (Sally Hinkle.)

Charles Street Fair

Shown here clockwise from left are Sabrina Fondren, Kristina Mead, and Nicholas Mead, who are enjoying the Charles Street Fair with the Mead children's aunt, Edie Holway, sometime in the early 1970s. The fair went on every September for 18 years, sponsored by the Beacon Hill Civic Association. It ended its run in 1988 when, with 40,000 people attending, it became too hard to manage. Now instead of a fair, there is a block party. (Frank Mead.)

John Winthrop Sears

A young John Sears is probably at work at one of his civic duties in this photograph. There were many of those. As a Yankee Republican, he was a leader in the moderate wing of the Grand Old Party. He has held or run for most offices in city and state government. He served in the Massachusetts House of Representatives, as the sheriff of Suffolk County, on the Boston City Council, and as Metropolitan District commissioner, the organization that now, under the name of the Department of Conservation and Recreation, manages Massachusetts state parks. He started the tradition of cleaning up the banks of the Charles River, grew the Fourth of July celebrations at the Hatch Shell, and built the North End's Steriti Ice Rink. He ran unsuccessfully for governor, mayor, and secretary of the commonwealth.

John is descended from many of the people mentioned in the beginning of this book, including John Winthrop. His great-great grandfather David Sears built the granite mansion on Beacon Street that now houses the Somerset Club. John lives more simply in a small house on Acorn Street filled with memorabilia.

In 1976, walking home, he was beset upon by two knife-wielding robbers. Sears stands six feet, three inches tall, and he had an umbrella in his hand. He decided to fight. They fled.

He is an example of the best kind of Boston Brahmin—well educated, civic minded, witty, generous, and welcoming to all. He is the neighborhood's Grand Old Man. (BHN.)

Toni Norton and Hill House

In 1965, families had no community center on Beacon Hill where children could take classes, teens could drop in, and meetings could take place. Moreover, both the Beacon Hill Civic Association and the growing nursery school needed a permanent location.

Bettina Antonia diStefano Norton, called Toni, became concerned about the situation. Except for boarding school and her stint at Wellesley College, she had lived on Beacon Hill her whole life. In fact, she had lived in the same row house on the short walkway, Rollins Place, since 1941 and, having married John Norton, was raising their children there.

In 1966, her friend Cynthia Fleming told her that the city was going to sell old Police Station No. 3 at 74 Joy Street, so pledging $1,000, she set out to procure it for the neighborhood. The civic association offered support, as did the Beacon Hill Nursery School.

With the assistance of the executive director of the association, Toni put together the proposal for a community center and marched to city hall. After a public hearing and with legal and political help from John Bok, Hill House acquired the site for $1. The group raised $94,000 for renovations. Landscape architect Diane McGuire designed a playground for the nursery school, and architect Joe Eldredge transformed the musty interiors, complete with a cellblock and nine dead cats, into cheerful space.

Norton became Hill House's first president, later worked in area museums, and still writes about art, music, and Boston architecture and history. She helped raise money for the Boston Public Library and founded and edited the *Beacon Hill Paper* and the *Beacon Hill/Back Bay Chronicle* from 1995 to 2001. Recently, she has led popular courses through Beacon Hill Seminars; in one, participants explore other neighborhoods of Boston.

She still lives in the house on Rollins Place in which she grew up. (Toni Norton.)

Frederick "Tad" Stahl

In the spring of 1963, architect Tad Stahl might have been spending his time designing the high-rise at 225 Franklin Street in Boston's Financial District. That building would be completed in 1966 with "State Street Bank" emblazoned around its top. Or he might have been working restoring his family's Egyptian Revival–style house on Hancock Street.

Instead he was focused on a neighborhood matter—one that would test the eight-year-old Beacon Hill Historic District designation.

Architect and Beacon Hill resident Eduard H. Bullerjahn and his partner Andrew Hepburn Jr. had acquired an option to buy 70–72 Mount Vernon Street and the Chestnut Street building behind it from Northeastern University.

The Thayer brothers, known for their antagonism to one another, had commissioned the 1846 buildings in the Victorian style. Boston University's School of Theology occupied the buildings and, later, the New England School of Pharmacy moved in. In 1962, it relocated to the Northeastern University campus.

Bullerjahn proposed to demolish the buildings, replacing them with his own contemporary design for luxury apartments.

The neighborhood divided into two camps, drawing 300 people to meetings. The matter would have to go before the Beacon Hill Architectural Commission. But first, one commissioner would have to resign: Andrew Hepburn Sr., the father of one of the developers.

The questions were thorny and novel. The pharmacy school's buildings were of a different era than the buildings on either side. Their bulk and material interrupted a cohesive line of brick townhouses. Does one preserve only one era in a historic district? Or does the district's entire history merit saving.

The early 1960s had seen the old West End's destruction and the hope that the new buildings in that neighborhood would bring Boston into a modern, prosperous era. Did that theory of rejuvenation extend to Beacon Hill?

Tad helped lead the fight to save the buildings. In August, the architectural commission rejected the proposal. It eventually approved slight modifications to the exterior. The architects gutted the building's interior and built condominiums.

The exterior was saved, but whether the interior is satisfactory is disputed. But the interior, not subject to the architectural commission anyway, is itself now part of Beacon Hill's history. (Jane Stahl.)

Andrea Gargiulo

Thirty years ago, Andrea Gargiulo, an assistant district attorney, was invited to a private club on Commonwealth Avenue. The doorman refused to let her in through the main entrance. "Women have to enter through the side door," he said.

The opportunity for retaliation came. Andrea was named chair of the Boston Licensing Board, which regulates the sale of alcohol, and Boston's private male clubs enjoyed their fine alcoholic beverages.

In 1987, the licensing board acted: clubs could discriminate if they chose, but they would not be eligible for a liquor license.

Boston's male clubs opened their doors to everyone, and nothing bad happened. (Andrea Gargiulo.)

Linda Cox

Linda Cox and Susan Timken bought the Book Store in 1978. Customers entered through a tunnel under the building. Its children's section was cozy, and its adult section was up to date. It closed in 1994, but Linda remains a strong community member. She helped found the Charles River Esplanade Association. Her book *Lone Holdout* tells the story of her experience as the lone holdout juror in the drug trial of a young Hispanic man. (Linda Cox.)

Tom Kershaw

The most common question residents get from tourists is—"Where's Cheers?" The eponymous basement bar, the inspiration for the television show that ran from 1982 to 1993, is at 84 Beacon Street.

Tom Kershaw owns the Hampshire House, which Cheers occupies. He is shown second from right with members of the later cast. The Philadelphia-born Kershaw started out as an engineer, but soon realized his gregarious nature was more suited to hospitality. In 1969, he and Harvard Business School classmate Jack Veasy bought the Georgian Revival mansion, then being operated as a small hotel. It had been built in 1910 as a stately family home. Its interiors were lavish, its rooms were ample, and its staircase was divine.

The first change the men made was to install the Bull and Finch Pub—after Charles Bulfinch—in the basement. They upgraded floors above into what Kershaw calls an "entertainment emporium" with a cocktail lounge and an elegant library overlooking the Boston Public Garden.

In 1977, having expanded to other locations, the men dissolved their partnership with each taking part of the business. Kershaw took the Hampshire House.

In 1981, Hollywood scouts came to Boston looking for a neighborhood bar around which they could develop a story. This city was first on their list because of its neighborhoods, politics, and sports teams. First on a list of pubs in the Yellow Pages was the Bull and Finch, so the team stopped in. They ordered beers and burgers and chatted with now-retired bartender Eddie Doyle. They had found their bar.

Although Cheers is famous, Beacon Hill knows Kershaw as a generous neighbor who offers his library for fundraisers and local events.

Kershaw has raised money for the Boston Common's holiday lights, the Freedom Trail, Bunker Hill Community College, and the Frog Pond ice skating rink. He ran the rink and the summer wading pool for nine years after they were renovated. Some suspect him of being the person who ties festive bows on the Make Way for Ducklings statues in the Public Garden.

Kershaw's staff helps in his endeavors. "Many of our people have been here over 20 years and make good money," he says proudly. Kershaw, now 75, will not retire. He lives on the top floor of the Hampshire House. A good business, a short commute, a loyal staff, and respect from the neighborhood—public life does not get much better than that. (Tom Kershaw.)

Nancy Schön

In 1941, Robert McCloskey wrote a story about a mother duck who leads her ducklings across busy streets from the Charles River Esplanade to the Public Garden with the help of a policeman. He illustrated it with scenes of the Charles River and Beacon Hill. Children loved it.

Urban planner Suzanne deMonchaux asked local sculptor Nancy Schön if she would be interested in creating a bronze replica of Mrs. Mallard and her brood for the Public Garden's 150th anniversary, and, of course, Nancy was.

Nancy Coolidge, then director of Historic New England, spearheaded the fund raising. The Friends of the Public Garden came on as a sponsor. Approvals were secured from various city officials, and Schön went to work. The ducks were installed in 1987 along a path near the intersection of Beacon and Charles streets. They are easy to find because there is always a crowd.

Since then, Schön has made one replica of the Mallards. The First Lady Raisa Gorbachev of Russia asked for them, and they now march in Novodevichy Park in Moscow too. (Nancy Schön.)

The Vilna Shul

Rabbi Moshe Waldoks married Steven Hatch and Miriam Tuchman at the Vilna Shul on Phillips Street in 1998. They were the first couple to wed there in 55 years. They were able to do so because this 1919 synagogue was saved.

In his twenties, Steven had a habit of wandering around Beacon Hill, he said. After he saw the Vilna Shul he suggested to Miriam that they hold their wedding there. Miriam was enthusiastic because, as an architecture student, she had worked on plans for its restoration. But neither Steven nor Miriam knew the neighborhood's Jewish history.

Eastern and Southern European immigrants arrived in Boston in great numbers at the end of the 19th century. Many lived on Beacon Hill's north slope and in the neighboring West End. By the 1920s, 10 percent of Boston's population was Jewish. Lithuanian immigrants founded the Vilner Congregation.

The congregation first worshiped in the Black Twelfth Baptist Church at 45 Phillips Street, where Wendell Phillips and William Lloyd Garrison had fueled the hearts of the abolitionists. The city demolished that property to build a school. Before the church was razed, the congregation salvaged the pews and installed them in the new Vilna Shul. So the pews in the shul have served worshipers for almost 170 years.

Partly because the old West End was destroyed and partly because the descendants of those immigrants were prospering and moving away, the Vilner Congregation dwindled. By 1985, the building was no longer used.

A group of Jewish leaders gained control over the building, stabilized the crumbling structure, and opened it as the Center for Jewish Culture. It is open to the public for tours as well as a place to celebrate Jewish holidays, weddings, and other festivities.

Steven and Miriam now have 12-year-old twins Erez and Ariella and two cats and live in Newton. (Steven and Miriam Hatch.)

CHAPTER SIX

A 21st-Century Neighborhood

Today, Beacon Hill is fortunate. It enjoys strong leadership through the Beacon Hill Civic Association. Its museums, organizations, and schools foster community spirit. Its housing is handsome. Crime is almost nonexistent, and city services are excellent. Those pictured in this chapter represent the continued deep participation in the neighborhood and beyond.

Having at the neighborhood's edge large hospitals, Suffolk University, and the Massachusetts State House, the original impetus for the neighborhood's development, is challenging. These institutions can seem overbearing when they want to expand or change. But it is complicated. Beacon Hillers use these institutions. Visiting one's state representative or physical therapist is only a 10-minute walk away.

Housing is expensive. But Beacon Hill residents have created subsidized housing in five large buildings and will do so again when buildings become available. This is no gated community. Beacon Hillers are proud of that.

One of the neighborhood's most satisfying attributes is that residents are forced to live cooperatively and in the public realm. They share walls, passageways, and sometimes yards. When they leave their homes, they interact immediately with others. After a snowstorm, everyone is on the streets together, shoveling, digging out cars, or collecting fallen tree limbs. Block parties bring neighbors together. Residents gather to fill barrels with flowers or take care of a strip of garden along a sidewalk. In December, Beacon Hillers together decorate every lamppost on the hill with laurel ropes and bows. In the fall, the civic association sponsors a neighborhood block party, and residents host a community dinner to which all are invited. It is held outside on that rare street—one that is almost flat. Halloween is legendary because neighbors decorate their doorways and greet thousands of trick-or-treaters from all over the city. It is easier to fill a candy bag if doorways are only 20 feet apart.

Because the small commercial district has almost everything one needs, residents tend to get their goods and services within a 15-minute walk. So it is impossible not to know the shopkeepers, many of whom live in the neighborhood too.

There are complaints. Absentee landlords typically do not care for their buildings as well as do resident landlords. Nevertheless, they charge high rents, which forces renters to take in more roommates than would be ideal. The young people in this situation are believed to cause the loud, late parties that bring the police.

Parking is a struggle. Many find it best to do without a car.

The most common complaints are about those who do not pick up after their dogs and who put out their trash improperly or at the wrong time.

The biggest problem in the neighborhood is the lack of a walk-to public school. This forces some young families out to the suburbs where schooling is less complicated.

All in all, Beacon Hill residents can seem a smug lot. After all, they were smart enough to realize how satisfying life here would be.

Local Presidents

In 1997, several presidents of the Beacon Hill Civic Association were gathered in one spot. Seated are Peter Thomson (left) and Eric Witherby. In the back row, from left to right are Robert Fondren, Bernie Borman, John Bok, Gael Mahony, Joel Pierce, Frank Mead, Bill Rizzo, Ed Lawrence, Susan McWhinney-Morse, Carolyn Ross, and Robert Owens. (BHCA.)

The photograph on the facing page shows some of the presidents at the association's annual Winter Gala. From left to right are Steve Young, Keeta Gilmore, Gene Clapp, Sandra Steele, Bob Owens, and Ania Camargo. (BHCA, Susan Symonds, Infinity Portrait Design.)

Robert and Elizabeth Owens

Sharing is typical on Beacon Hill because a building's history can be complicated. Bob and Biddy share a garden behind their Mount Vernon Street house with a small Arts and Crafts building on Pinckney Street.

Their house and the Pinckney Street building for more than a century had the same owner. It started as a stable and over the years was used as a shop or a residence. In the late 1800s architect William Ralph Emerson transformed it into a dwelling known now as "the house of odd windows," since no window is the same. When the houses were sold to two different owners, the best thing to do with the yard was to share it.

The Owenses are like many residents in that they have focused on historic preservation. Bob has served on the boards of Historic New England and Historic Deerfield. Biddy and Bob helped found the Historic New England Council, whose members keep watch for preservation threats and opportunities. They have renovated and restored three houses on Beacon Hill to ensure that updating would be sensitive to the style of the house. (Susan Symonds, Infinity Portrait Design.)

Judy Avery

In 1990, Judy Avery, shown here with helper Jim Higgins, wanted to showcase her favorite artists. She also wanted to encourage neglectful landlords to clean up the old walkways around their properties. So she started the Beacon Hill Art Walk, where fine artists can exhibit their work and sell them. Each year on the first Sunday in June, the Beacon Hill Art Walk takes place in the nooks and crannies of the hill's north slope. (Jennifer Matson.)

Babak Bina

Babak Bina owns two restaurants on the hill, Lala Rokh and Bin 26 Enoteca, but he finds time to distribute brooms on Cleanup Day, a semiannual effort that gets debris hand-swept into the trash. (BHCA.)

Carl Scovel and Joy Fallon

Kings come and go, revolutions happen, and attitudes change. The Revs. Carl Scovel and Joy Fallon show how old institutions survive with good leaders, changing outlooks and a history to treasure.

Dr. Scovel served as King's Chapel's minister from 1967 to 1999, living in the parish house on Beacon Street and becoming a voice in the community. Reverend Fallon served as legal counsel to Governor Dukakis before she enrolled in divinity school. Now, she leads King's Chapel. (Author photograph.)

Winter Gala

Since 1972, the Beacon Hill Civic Association's Winter Gala has brought out the whole neighborhood for a dressy evening of dining and dancing. Tom and Mary Fran Townsend of Chestnut Street show how it is done. (BHCA.)

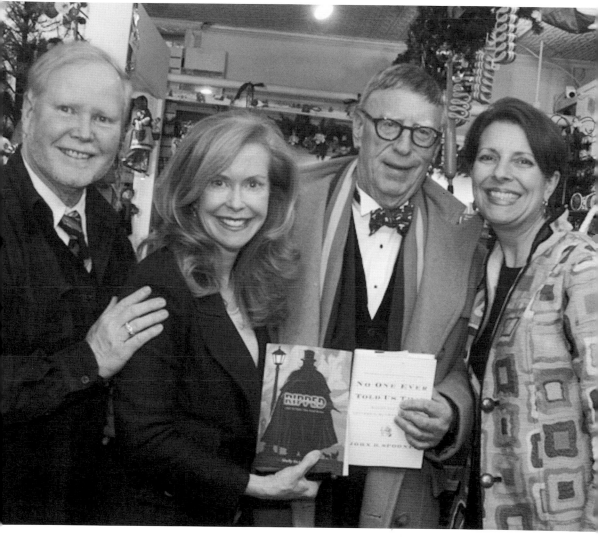

Mark Duffield and Jennifer Hill

Blackstone's threw a party in spring 2013 at which local author Shelley Dickson Carr, second from left, signed her recently published young adult mystery *Ripped*, which naturally involves Jack the Ripper. Shelley's real name is Michelle Karol.

Also signing books that evening was John Spooner, second from right, an investment advisor and author of *No One Ever Told Us That: Money and Life, Letters to My Grandchildren*, his fifth nonfiction book. He is also the author of two novels.

Blackstone's owners, Mark Duffield, at left, and Jennifer Hill, far right, are enthusiastic participants in all community undertakings.

This chockfull gift shop was established in 1982 by Dick Dowd, who sold it to Lynne Miller; Miller then turned it over to Mark and Jennifer in 2006. All the owners have been local. (Mark Duffield.)

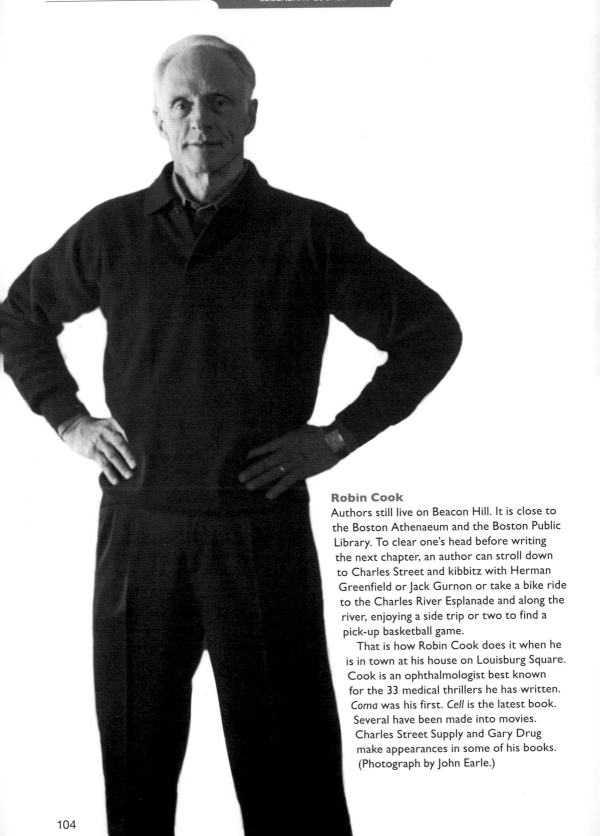

Robin Cook

Authors still live on Beacon Hill. It is close to the Boston Athenaeum and the Boston Public Library. To clear one's head before writing the next chapter, an author can stroll down to Charles Street and kibbitz with Herman Greenfield or Jack Gurnon or take a bike ride to the Charles River Esplanade and along the river, enjoying a side trip or two to find a pick-up basketball game.

That is how Robin Cook does it when he is in town at his house on Louisburg Square. Cook is an ophthalmologist best known for the 33 medical thrillers he has written. *Coma* was his first. *Cell* is the latest book. Several have been made into movies. Charles Street Supply and Gary Drug make appearances in some of his books. (Photograph by John Earle.)

Surprises

In a city, one never knows what he or she will see. For example, there could be a contraption pedaled by four people or police officers on handsome horses. Even the people whose names we don't know become legendary. (Both, BHT.)

Beverly Morgan-Welch

Beverly Morgan-Welch has led the Museum of
African American History since 1999. It incorporates
the 1834 Abiel Smith School, the first building in
America built as a public school for black children,
and the 1806 African Meeting House, which hosted
such abolitionists as William Lloyd Garrison. Beverly
recently supervised the restoration of the building to
its vibrant 1855 appearance, with pale-yellow walls and
egg yolk–colored pews with red cherry-wood trim.
(Don West, fotografiks.)

Laury Coolidge

After 40 years, Lawrence "Laury" Coolidge is still
clearing brush, trimming bushes, and pruning the trees
on the Esplanade, which stretches along the Charles
River between the Museum of Science and Boston
University bridges. The Charles River is a busy river
with rowers, kayakers, pleasure boaters, Duck Boats,
cormorants, mallards, black-crowned night herons, and
even swimmers when the Charles River Swimming Club
holds its annual swim. (Author photograph.)

Keeping a Legacy Alive

Flavia Cigliano, executive director; Bill Pear, historian; and June Hutchinson, past president of the board of governors, from left to right, keep the Nichols House Museum in the shape Rose Nichols wanted it to be kept and open to the public. June Hutchinson is also the author of *At Home on Beacon Hill: Rose Standish Nichols and Her Family*. (Photograph by Edward Jacoby.)

Joel and Martha Pierce

When a neighborhood establishes a historic district commission to oversee its buildings, someone must run it. Meet Joel Pierce, who has chaired the Beacon Hill Architectural Commission since the 1990s. He and the other commission members hear requests for changes to Beacon Hill's buildings at city hall. Hearings can be heated, but Joel keeps things cool.

The Pierces raised their children on the hill and sent them to public schools. Martha was Mayor Menino's education advisor. (Joel Pierce.)

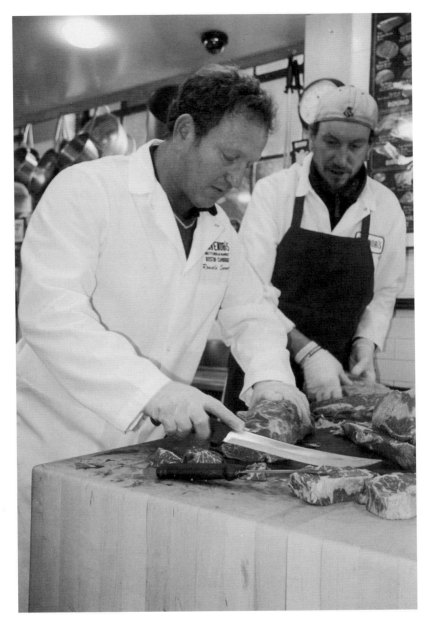

Ron Savenor

Ron Savenor shows fellow butcher Tom Daly how it is done in the Charles Street gourmet grocery he opened in 1993. He was carrying on his Lithuanian family's tradition. Ibraham, Ronnie's grandfather, opened a butcher shop and grocery in Cambridge in 1939. Ron's father, Jack, took it over on his father's death in 1942 and gained fame as Julia Child's favorite butcher. Ron took over from Jack in 1987. When the Cambridge store burned in 1992, it was a blow to both the Savenors and Boston's cuisine culture.

To get back on his feet, Ron opened the Beacon Hill store, selling the family's typical prime meat, game, and such specialty meats as alligator and ostrich.

In 2005, Ron reopened the Cambridge store. Savenor's trucks are parked along streets all over Boston because Savenor's has a large business supplying meats and specialty products to high-end caterers and restaurants. (Author photograph.)

Gene and Meredith Clapp

Gene and Meredith Clapp are typical of many Beacon Hill couples. They have raised their four children here and been leaders in the community for many years. Gene has served as a chairman of the Beacon Hill Civic Association, among other activities. Meredith was a president of Hill House. Both have stepped in to solve difficult problems and have raised money for needy causes.

It was while Meredith was president that Hill House underwent many changes, moving from its historic quarters on Joy Street to an unused former firehouse on Mount Vernon Street, donated to the community by the city, just as 74 Joy Street was in 1966. While most of the community was behind the move, a few neighbors objected and had to be won over.

This community center has had enormous success at its new location, and the disturbances some neighbors predicted have not occurred. Hill House now serves more than 2,000 children in classes, sports teams, and summer programs at both its old and new locations. Adults get involved in classes, pancake breakfasts, Christmas tree sales, and senior dinners. While many of its members come from the hill, children from all over downtown Boston take advantage of its offerings. (Meredith Clapp.)

Sharon Malt

Sharon Malt decided while she and her husband, Brad, lived on the hill and raised their children, she would volunteer.

She has earned respect for her good judgment, reliable follow-through, and problem-solving skills. She has led or served on the boards of Hill House, Beacon Hill Seminars, the garden club, the Greater Boston Youth Symphony Orchestras, the civic association, the Circle for Charity, and the Charles River Watershed Association, as well as the Esplanade's Teddy Ebersol's Red Sox Field project. (Brad Malt.)

Beatrice and Peter Nessen

It is easy to become involved in government when one lives next to the seats of power. Peter was secretary for administration and finance for Governor Weld. Beatrice worked on the Big Dig and on the boards of Light Boston, which illuminates Boston's historic architecture, and the Friends of the Public Garden. Beatrice took on an unusual project, helping establish the Garden of Peace, a small plot near Bowdoin Street intended to build awareness about society's violence by commemorating those who have been homicide victims. (Beatrice Nessen.)

Paula O'Keeffe

Paula O'Keeffe has been Beacon Hill's representative to the Boston Police's Area A-1 Safety Committee for more than a decade as part of the police department's community policing program. A few years ago, she received an award from Mayor Tom Menino for her tenacity in keeping in touch with the police. Paul Scapicchio, at right, then a Boston city councilor, joined Menino in congratulating her on her award. (BHCA.)

Eugene Galleries

Barbara Fischer bought this Charles Street antiques shop more than 30 years ago. It is crowded but well organized with prints, engravings, beautiful old books, and general ephemera. Her mother came from Germany to help her, and they took this picture. (Barbara Fischer.)

Houghton, Besser, and Burnes

It is the first Saturday after Labor Day. Neighbors are back from their summer activities, and people would like to catch up. James Houghton, Suzanne Besser, and Gordon Burnes, pictured checking in people, dreamed up Harvest on the Hill to gather neighbors together. This annual outdoor 200-plus dinner party is an invitation-only event for Beacon Hill residents and takes place in the middle of a city street. It is what this neighborhood specializes in—having fun, which is a welcome to all, and sharing a public space. (John Besser.)

Beacon Hill Village and Beacon Hill Seminars

John Spooner, Deborah Leighton, Ann van Nostrand, and Frank Mead, one of the founders of Beacon Hill Village (BHV) and Beacon Hill Seminars, and former BHV executive director Judy Willet do what Beacon Hill Village members do best—enjoy a party.

In the late 1990s, several older Beacon Hill residents began meeting. They were concerned they would have to leave their homes as they aged. Sure, their stairs were steep. But they had been negotiating them most of their lives. They had strong ties to Beacon Hill. They wanted to stay among friends of all ages. They wanted to keep their convenient city style of life.

They investigated. They talked to people nationwide. And in 2002, they started Beacon Hill Village, an organization that provides its members with programs and services that enable people to stay in their homes as they age.

Early on, the discussions spawned Beacon Hill Seminars in which members over the age of 50 teach and take classes in all kinds of subjects. Now, many Beacon Hill residents are members of both organizations. (Frank Mead.)

Myrtle Street Playground
Eleanor Davol has put all her eggs in one basket at the annual Easter Egg Hunt at the Myrtle Street Playground. Myrtle Street and Phillips Street are two playgrounds on Beacon Hill. The Tadpole Playground at the Frog Pond on the Boston Common and the Esplanade's Stoneman Playground are two more within a child's walking distance. (BHT.)

Charles Street Shop Owners
Charles Street shop owners (from left) Suzy O'Brien of Red Wagon; Carol White of the former antiques shop, Churchill & White; and Karen Fabbri, owner of Moxie, enjoy Tom Kershaw's hospitality at a Beacon Hill Business Association party a few years ago. Kershaw was the founder of the Beacon Hill Business Association. (BHT.)

Sally Brewster

Sally Brewster started in real estate in 1971, when her kids, David, Annie, and Jennifer, shown here in the stroller, were little. Information about listings and sales were passed by word of mouth and personal connections. Buyers, sellers, and brokers depended on the listings published in the Sunday classified ads. There were no listing services and certainly no Internet.

Apartments had not yet become available for condominium ownership, so the sales were all either single houses or multifamily rental buildings.

By the mid-1970s, that was changing as rental units were converted to condos. Today, the majority of sales are condominiums. On Beacon Hill in 2013, there were 27 townhouse sales and 138 condominium sales.

Prices increased all over Boston, but especially in historic districts, like Beacon Hill, where there is little room for expansion or new housing. A condominium at 61 Mount Vernon Street that sold for $73,000 in 1973 sold in 2011 for almost $3 million. At 46 Mount Vernon Street, the price of a townhouse increased from $90,000 in 1975 to more than $2 million in 1996 to almost $5 million in 2011. In general, owners keep their homes in good condition. After all, people today are temporary caretakers for homes that have been occupied for between 100 and 200 years, and those buildings will still be occupied for a long time to come.

The arrival of personal computers and data communication in the 1980s offered increasingly more information about real estate listings, and the Internet vastly expanded that. Today, a broker would not think of bypassing the Internet. But the core nature of the real estate business has remained much the same as years before: word of mouth and personal connections still play key roles. (Sally Brewster.)

Lynne Wolverton

Beacon Hill's business district still has some handy antiques shops when a person is after a nice cherry dresser. It also has many home decorating shops. Linens on the Hill, started by Lynne Wolverton in 1987, is one of those. It carries fine linens, of course, but also small gift items, soaps, and nightgowns. Lynne is shown here at a sidewalk sale a few years ago. (BHT.)

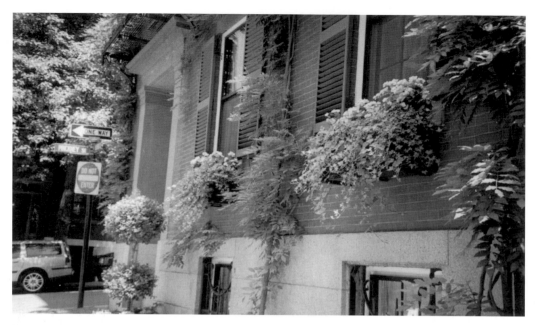

Jeannette Herrmann

Window boxes are prized on the hill. Those at John Kerry's house, above, always look good.

Jeannette Herrmann (center), former president of the civic association, and Betsy Madsen from the garden club present Beacon Hill resident Al Holman with his award at the Window Box Contest celebration. Holman has a small side yard visible from the street, which he plants beautifully, delighting all his neighbors. (BHT.)

John Corey and Miguel Rosales

These Mount Vernon Street residents are leaders in helping to maintain Beacon Hill's streets in an aesthetic, pedestrian-pleasing way. John is a real estate investor and developer; Miguel is a bridge designer. Both are graduates of the MIT School of Architecture and Planning.

John was a prime mover in getting tree guards and plants installed around the trees on Charles Street. He also worked with the city to repair the brick sidewalks along the street and helped implement a new parking plan along the entire street.

Miguel was one of the architects working on the Leonard P. Zakim Bunker Hill Bridge, a part of Boston's "Big Dig." Miguel also designs footbridges throughout the country, including one that will cross over Storrow Drive connecting Charles Circle to the Charles River Esplanade when the Longfellow Bridge construction is finished. Miguel is also the lead architect for the rehabilitation and restoration of that century-old bridge. (Susan Symonds, Infinity Portrait Design.)

Swan Boats

Swan Boat rides in the Public Garden have been entertaining children since 1877. It is this baby's first ride. (BHT.)

Robert Beal

Robert Beal can usually be found at his desk at Related Beal or at one of the projects owned by the real estate development company started by his family in 1888. In the 1980s, Robert was an early Beacon Hill homeowner to notice his house was tilting because its pilings were rotting.

Robert lives on filled land on the flat of the hill. Early builders supported the houses on wooden pilings sunk deeply into the ground. All was fine if the pilings were kept wet. But over the years, the water table fluctuated, and exposed pilings rotted. At vast expense, most of the estimated 188 buildings potentially affected by this problem have been fixed. Houses in other neighborhoods are at risk too. In 1986, the Boston Groundwater Trust was established to monitor ground water. So far no building has fallen down. (Robert Beal.)

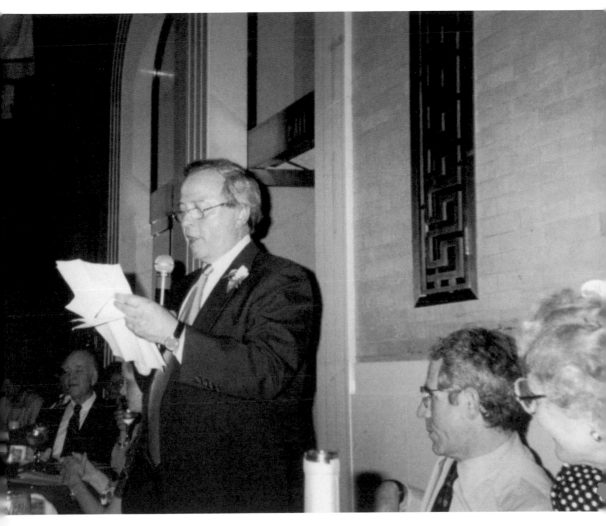

Myles Striar, Local Bard

For 20 years, Myles Striar has entertained readers of the *Beacon Hill Times* with his wit and wisdom expressed in doggerel in "Myles's Musings." Sometimes, he is asked to compose a ditty for an occasion, as he did here when the Beacon Hill Civic Association presented the first Beacon Award. Below, "Progress on Beacon Hill," with thanks to Sally Brewster, is a short sample of his style. (BHCA.)

> *Nail salons are popping up.*
> *The bookstores that we loved are gone.*
> *Makes sense, of course. You still can't fix*
> *Your cuticles on Amazon.*

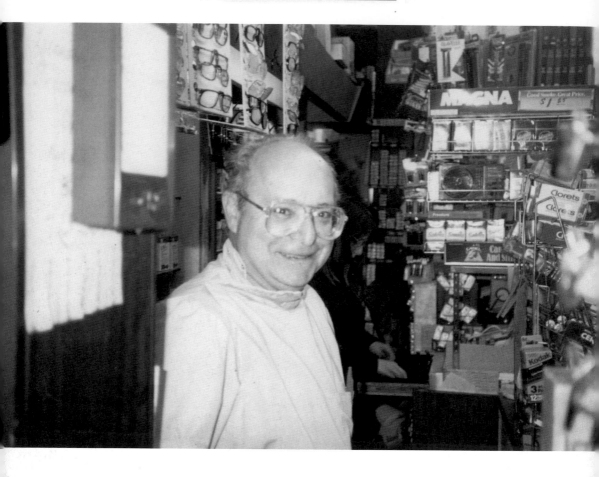

Herman Greenfield

Herman Greenfield bought Gary Drug in 1972, but he did not change it much. He carried Pear's soap, Kent brushes, and Brylcreem, as he still does. Before there were ATMs, Gary Drug cashed checks. The drawers have always held people's house keys. Gary Drug has almost 300 charge customers and about 100 people who rely on deliveries only and may never have been in the store.

In 1978, Herman bought the building Gary Drug is in. He now lives upstairs, as does his longtime shop manager, Eileen Fitzpatrick. Five clerks help the steady stream of customers find products that stretch to the ceiling.

Pharmacist Rich Lane has been at Gary Drug almost 40 years. Herman's son Dan is now an on-site pharmacist and part owner of the store. Herman is still on the job too. Residents will recognize Herman, Eileen (opposite page, top image), and Rich (opposite page, bottom image) from earlier days. (All, Herman Greenfield.)

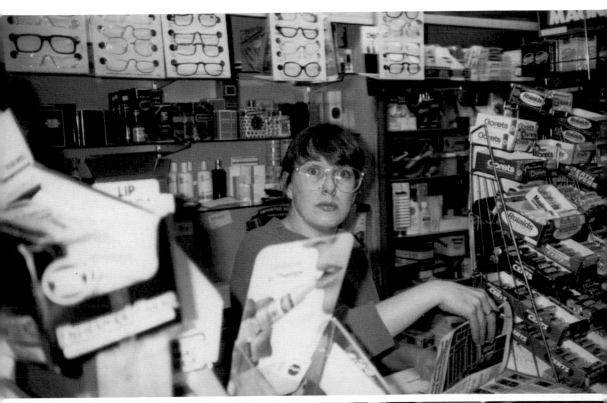

Constant Cleanup

With so many people using the sidewalks for getting about, setting out trash, and walking dogs, Beacon Hill residents seem to be cleaning them all the time. Bob Matson tidies a tree pit, while Rob Whitney, son Adam, and Lori Bate sweep up fall leaves. These people have always led cleaning efforts. (Above, BHCA; right, BHT.)

The Future Legendary Locals of Beacon Hill
Pictured is Priscilla's Green Room class of three-year-olds at the Beacon Hill Nursery School. (Beacon Hill Nursery School.)

INDEX

INDEX

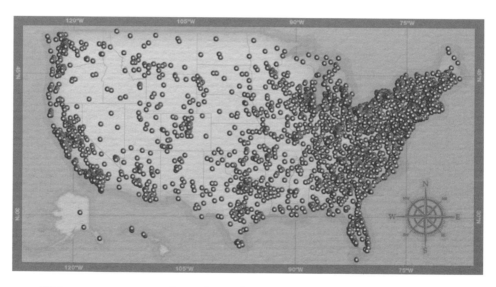